Scatter Garden Quilts

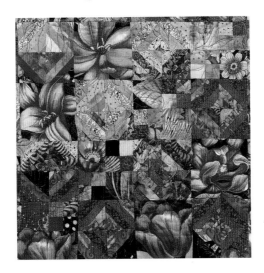

10 Designs That Flower in Fabric

Pamela Mostek

Martingale®
& COMPANY

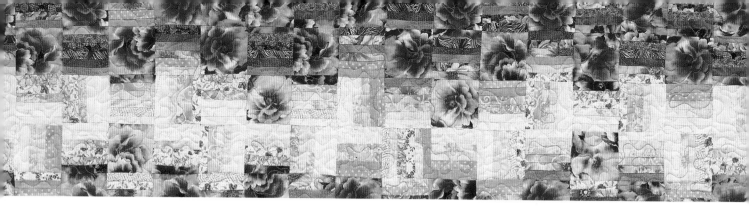

Scatter Garden Quilts:
10 Designs That Flower in Fabric
© 2005 by Pamela Mostek

That Patchwork Place® is an
imprint of Martingale & Company®.

Martingale & Company
20205 144th Avenue NE
Woodinville, WA 98072-8478 USA
www.martingale-pub.com

Printed in China
10 09 08 07 06 05 8 7 6 5 4 3 2

Credits

President: Nancy J. Martin
CEO: Daniel J. Martin
Publisher: Jane Hamada
Editorial Director: Mary V. Green
Managing Editor: Tina Cook
Technical Editor: Darra Williamson
Copy Editor: Melissa Bryan
Design Director: Stan Green
Illustrator: Brian Metz
Cover and Text Designer: Stan Green
Photographer: Brent Kane

Library of Congress Cataloging-in-Publication Data

Mostek, Pamela.
 Scatter garden quilts : 10 designs that flower in fabric / Pamela Mostek.
 p. cm.
 ISBN 1-56477-583-6
 1. Patchwork—Patterns. 2. Quilting—Patterns. 3. Gardens in art. 4. Flowers in art. I. Title.
 TT835.M698 2005
 746.46'041—dc22

 2004020679

Mission Statement
*Dedicated to providing quality products
and service to inspire creativity.*

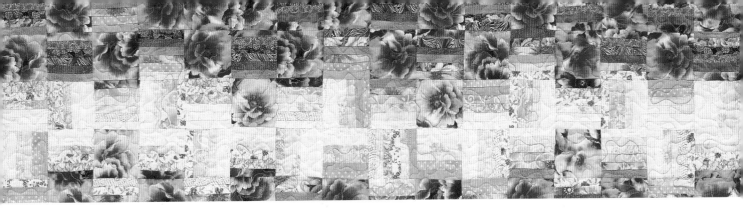

Dedication

To the memory of my mother, Eula Sims, who taught me to see, love,
and create beautiful things . . . and did it with such joy and enthusiasm.

Acknowledgments

In putting together this, my fifth book, I'm reminded once again of all those people who have supported, critiqued, encouraged, and assisted me in getting it all done. Here are a few of those people who deserve a special thank-you.

To my friends Edi Dobbins and Carol MacQuarrie who help me with my quilts: thank you for the enthusiasm, the hard work, and the sense of pride you put into your efforts. Working with you in a spirit of teamwork makes it all so much more fun. It just wouldn't come together so smoothly without you!

To Edi, my seamstress: special thanks for the extra hours and expert piecing you put in to help me with the quilts for this book. (With 20 quilts, there was more than enough piecing for both of us!) Thanks also for sharing instructions for your fabulous bindings.

To Carol, my quilter: thank you for always squeezing in my quilts at the head of the list, even after you've had a long day at your "real job."

To Martingale & Company, my publisher: thank you for once again having faith in my vision of a great book.

To Stan Green, the design director at Martingale: thank you for patiently listening to my input and ideas for the book design and for doing such a great job to bring it all together.

To Darra Williamson, my technical editor extraordinaire: it has been so nice knowing that my vision and my book are in such good hands.

To my daughter Rachel: thank you for your wonderful eye in critiquing my designs and for your unabashed honesty in pointing out the one quilt you just *didn't* like.

To my daughter Stacey: thank you for your long-distance support and for your assumption that everything I do will be wonderful.

To my husband, Bob: thank you for always being proud of what I create—and for running the vacuum too!

And to my beloved grandchildren, Josie, Brooklynn, Jared, and Lauren: you will always come first . . . even before quilting!

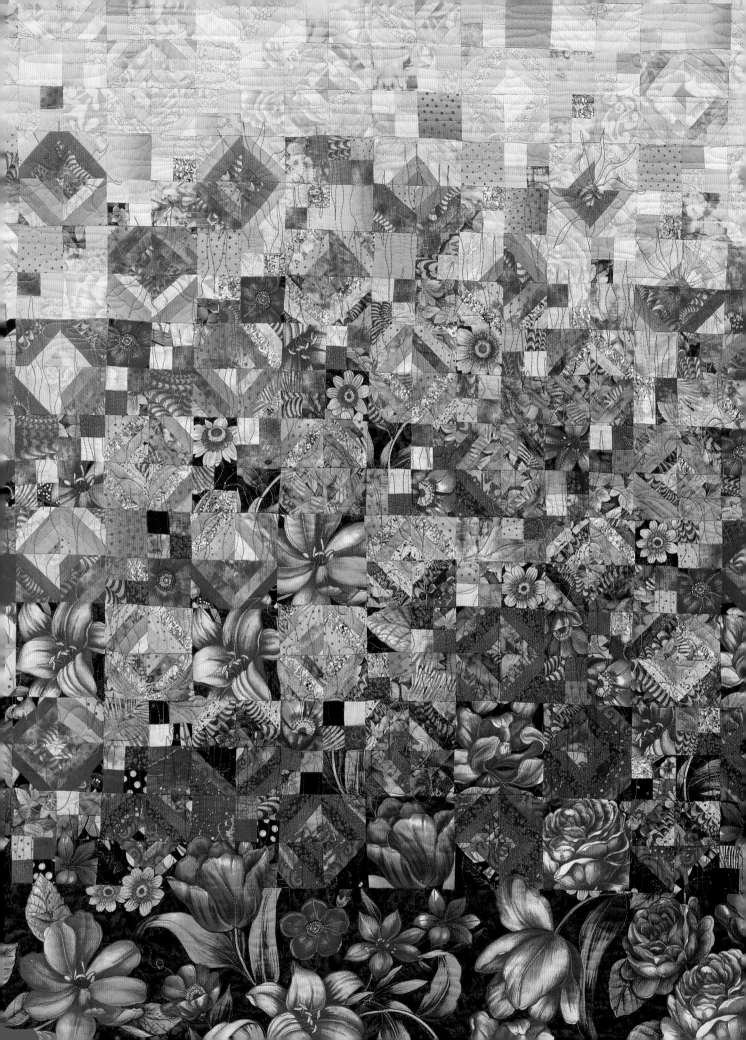

Contents

Plant a Scatter Garden Quilt

*F*OR ME, quilting is all about the fabrics. Not just any fabrics, but specifically those gorgeous and dramatic floral-print beauties. I love looking at them, feeling and fondling them, buying them, and reverently taking them home.

Then comes the hard part—using them! I just can't bear to slice and dice those fantastic flowers into tiny squares and triangles and to see all that gorgeous textile artwork become a remnant of its former glory. Sometimes after slashing these fabrics into pieces, I can *almost* see a semblance of the original beauty, but it's just not the same. There must be a way—I kept telling myself—to use these fabrics and yet hold on to the flowers that I first fell in love with.

And so began another chapter in my ongoing quest to *use* fabric while still maintaining its original character. In my book *Just Can't Cut It!* (Martingale & Company, 2003), I created designs to use fantastic fabric without cutting up the prints. This worked wonderfully, but—as always—I continued to look for yet another option. Then inspiration hit. What if I cut the fabric, but cut and used it with a new twist? Thus, *Scatter Garden Quilts* was born!

This book focuses on cutting *around* those lovely flowers and "sprinkling" them across a quilt, just as a gardener scatters seeds across the garden. When these carefully cut flowers are combined with other fantastic fabrics, the results are lovely, eye-catching quilts with all the charm of a cottage-style garden. Which brings up another of my favorite things: gardens ablaze with color, particularly the abundant, spontaneous look of English cottage-style gardens. Images of these beautiful gardens inspired me to create this unique collection of quilts.

Just as when you're planting a garden, there is always the opportunity to add your personal touch to a Scatter Garden quilt. As you look through this book, you'll see that each project includes a plan, or "garden map," for you to follow when sewing and arranging the blocks. If you prefer more creative freedom, I've also included ideas for making the blocks in many variations as well as ideas for placing the blocks in different arrangements using the garden map as a starting point.

Before you begin, take time to read through "Gardening Tips" (pages 7–15). There you'll find all you need to know about choosing the fabrics and using fussy cutting or *broderie perse* appliqué to scatter the flowers across your quilt. You'll also learn about the three types of blocks you'll need to make your Scatter Garden quilts: Flower blocks, Blender blocks, and Background blocks. Some of the quilts use all three block types, and others use just one, but with "zillions" of variations in color, value, and fabric print. All of the quilts, however, have one thing in common—they're all about showing off a fabulous fabric in a unique and exciting way.

So now you see that you don't need to chop the irresistible flowers on your fabric into strips and pieces. Instead, you can cut them to show them off, just as you cut the flowers for a scatter-garden bouquet to display in your home. In fact, cutting those flowers can actually be the very best way to showcase them. You just need to cut them the right way!

Enjoy creating your Scatter Garden quilt. And happy gardening!

—Pam

Gardening Tips

THE COLORFUL BLOOMS in your garden depend on the seeds that you scatter. Your garden takes on a look that reflects your own personality, based on which seeds you plant and where you choose to plant them. Your quilt, like your garden, can also take on your individual, personal touch. That's what this book is all about: creating quilts that are uniquely your own, each with the charm of a colorful scatter garden.

Each project in the book covers basic step-by-step construction, but your individual fabric choices and, often, your unique positioning of the blocks are the keys to making your quilt burst into bloom. Don't be afraid to experiment. Rearrange and rotate the blocks until you love the results. Remember, it's your garden! Have fun while you're creating it.

Before you plant your Scatter Garden quilt, there are a few tips and techniques to master so that your quilt, like your garden, will be a wonderful success. In this section you'll learn all the basics for creating a truly beautiful and one-of-a-kind creation.

Selecting Your Fabrics

Scatter Garden quilts are definitely all about the fabric. There are so many gorgeous floral prints available today that the hardest part might be choosing just one! The most important thing is to choose one that you *absolutely* love.

When I go shopping for that special fabric to inspire my quilt, I try not to form any definite image of how that fabric should look. If I narrow the possibilities to one particular color, style, or scale of print, it often becomes more difficult to find just the right piece. Instead, I allow myself to enjoy the hunt and see what I come up with. I feel certain that when I find it, I'll know! It practically jumps off the shelf into my arms. Well, OK, maybe it doesn't happen quite *that* dramatically, but somehow I always know the perfect fabric when I spot it on the shelf.

Whether you are fussy cutting the flowers and piecing them into the quilt or stitching them on using *broderie perse* appliqué, here are a couple of things to keep in mind as you shop for fabric.

Size and Shape of the Print

I like large-scale floral prints because they seem to create more drama when I scatter the Flower blocks across the quilt, but that's a matter of personal preference. Smaller flowers can produce a delicate effect, if that's the look you're after.

If you plan to fussy cut fabrics for your blocks, look for flowers that are close to being square in shape or that feature an area where you can cut a pleasing square of flowers, even if you include bits of background or foliage in the square. If the flower is too irregular, you

will cut much of it off when you position your square ruler on the flowers and trim.

When you fussy cut fabrics for your blocks, look for floral motifs that fill a square.

Of course, you can fussy cut the flowers irregularly and then the shape of the flower is not as important. I used this approach in "Sweet Hydrangeas" on page 23. Notice that the flowers are positioned in different parts of the fussy-cut blocks.

If you use traditional *broderie perse* appliqué to stitch the flowers to the pieced quilt, look for flowers with smooth edges. For example, a daisy, with its ragged, pointed edges, would be difficult to turn under for appliqué.

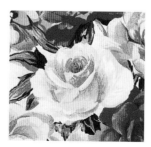

When choosing appliqué motifs from a printed fabric, look for flowers with fairly smooth, continuous edges, such as these, rather than jagged, irregular ones.

Position of the Flowers

Whether you are fussy cutting or appliquéing the flowers for your quilt, look for prints in which at least some of the flower shapes are complete rather than overlapped. It's hard to isolate and cut a single flower when each one spills over onto another. If some of the flowers overlap and others don't, the fabric will work fine. You will just need a little more fabric to cut out your favorites.

Look for prints in which at least some of the flower shapes are complete rather than overlapped.

The Leftover Fantastic Fabric

This talk of cutting into the fabric brings up a Very Important Subject—do not worry about the fate of the remaining yardage as you cut out those fantastic flowers. Don't panic when you finish fussy cutting flowers and the piece of fabric that remains looks like giant moths have made it their dinner! *It really is OK to use fabric this way.* The results will be worth it, and—happily—many of the quilts use the cut-up fabric in the scrappy blocks.

When you're finished cutting, trim what's left of the yardage into foldable pieces and add them to your stash. Undoubtedly, the wonderful colors in these large prints will work easily into other projects.

The "Other" Fabrics

Once you've found that perfect focal fabric for your Scatter Garden quilt, the next step is to select the fabrics to go with it. Many of the

quilts in the book, such as "Rambling Roses" (page 16) and "Tropical Tulips" (page 74), are scrappy and include dozens of different fabrics. This gives you a great chance to dig into your stash and use some of those small, precious pieces that were too special to discard. Add new prints by purchasing fat quarters or even eighth yards.

Use your focal fabric as a guide for selecting companion fabrics and colors. It's important to keep shade and intensity in mind as you choose these companion prints. For example, if your focal fabric is dark and dramatic, as in "Patti's Quilt" (page 54), look for similarly dramatic choices for the other fabrics. High contrast also adds pizzazz to a dramatic focal fabric.

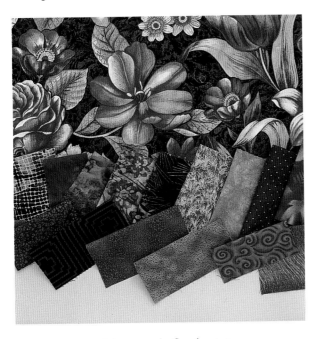

*A large-scale floral print
with coordinating fabrics*

On the other hand, if your fussy-cut or appliquéd flowers are soft and delicate, as in "A Garden Wreath" (page 82), choose fabrics in primarily the same shade for the other blocks. Since it's easy for a light and subtle quilt to look a bit washed out, you might want to add a few touches of a darker or lighter "zinger" fabric in the same color range. Add these

sparingly, however, as a little goes a long way! The touches of white in "A Garden Wreath" add just the right amount of sparkle to this delicate quilt.

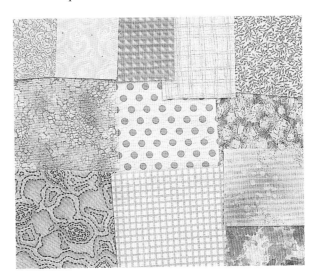

A variety of soft and subtle prints

Fussy Cutting

Fussy cutting means simply isolating a favorite motif in a fabric—in this case a fabulous flower—and cutting around it so it can be pieced back into the quilt as a block or part of a block. Simple, huh? It's a great technique for scattering focal-fabric blocks anywhere you want them in a quilt.

I use a see-through acrylic square ruler as a cutting guide to fussy cut flowers. I have quite an assortment of rulers in different sizes, since I never know when I might discover a great fabric for fussy cutting, and I want to be prepared! I *always* use a square that includes the seam allowance: primarily a 2½", 3½", 4½", 5½", 6½", or 8½" square, depending on the size of the flower I wish to cut. I prefer the square rulers made by Creative Grids; they have non-skid circles on the back to prevent the ruler from slipping as I cut the fabric. Check with your local quilt shop for more information about these rulers.

I carry several of these squares in my purse when I go searching for fabric. They're very handy for determining just how that captivating flower will look when it's isolated from the rest of the print.

I use a rotary cutter for cutting. I prefer a cutter with a smaller blade (12 mm) to cut around the smaller-sized squares, and one with a larger blade (60 mm) to use with the 6½" or 8½" square rulers.

Cutting Flowers

Here is the simple method I use to fussy cut flower squares for piecing.

1. Position the ruler over the flower you wish to cut. You may prefer to center the flower in each square or to move the ruler so that the position of the flower varies in each block.

2. Cut around the ruler carefully with the rotary cutter. Remove the flower block.

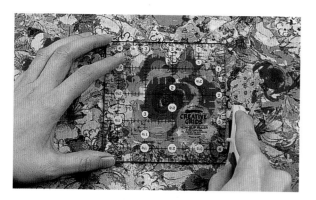

Broderie Perse Appliqué

This favorite appliqué technique of the nineteenth century is perfect for adding the beauty of today's fabulous florals to your quilt without chopping them into little pieces. No matter how large or how small the flowers in the print, you can easily cut and appliqué them to your Scatter Garden quilt.

For this technique, choose a fabric with flowers that have basically smooth edges. (See "Selecting Your Fabrics" on page 7.) Rounded curves and a few points are fine; just don't choose a flower with multiple layers of small petals. Multiple edges make it difficult to maintain the shape of the flower as you turn under the raw edges for appliqué.

Adding the Appliqué

Here are the simple steps I use to complete the appliqué.

1. Use scissors to cut around the flower you wish to appliqué, leaving a ¼" turn-under allowance on all edges.

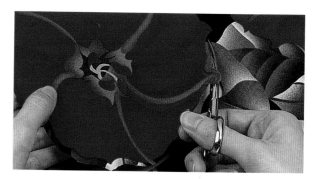

2. Clip any inside curves to the edge of the desired flower shape.

3. Finger-press the turn-under allowance to the back of the flower. You may find it necessary to smooth sharp corners or edges or to simplify the shape slightly to make it easier to turn.

4. Position and pin the flower on the quilt. Beginning on a gently curved edge of the appliqué shape, use the tip of the needle to turn under the finger-pressed allowance. Turn under about ½" at a time ahead of yourself as you sew using the appliqué stitch.

THE APPLIQUÉ STITCH

1. Tie a knot in a single strand of thread that closely matches the color of the appliqué.

2. Bring the needle from the wrong side of the appliqué up on the fold line and make a blind stitch along the folded edge. Take a stitch about every ⅛".

3. To end your stitching, pull the needle to the wrong side of the appliqué background. Take two small stitches, bringing your needle through the loops to make a knot. Trim the thread tails.

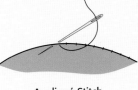

Appliqué Stitch

The Garden Blocks

Now that you've selected your fabric and learned how to scatter your flower motifs across the quilt—either by fussy cutting and then piecing them into the quilt, or by appliquéing them to the block or quilt background using *broderie perse* techniques—you're ready to put together your Scatter Garden quilt.

The flowers are the most important design element in your quilt. The other fabrics and blocks create backgrounds for the flowers or blend the colors to create a pleasing visual balance over the quilt surface. To keep the project instructions simple, I've divided the blocks into three types: Flower blocks, Blender blocks, and Background blocks. Many of the quilts include a combination of all three block varieties. Others use multiples of just one type of block created from a wide array of fabrics. Let's take a closer look at each of the different block types.

The Flower Block

A Flower block is generally a single piece—most often a square—cut from the quilt's focal fabric to spotlight a single large motif. In a few projects, such as "Rambling Roses" (page 16) and "Bouquets for Brooklynn" (page 61), flower squares are used as the center of a pieced Flower block. The instructions for each project tell you how many Flower blocks you'll need and what size to cut them.

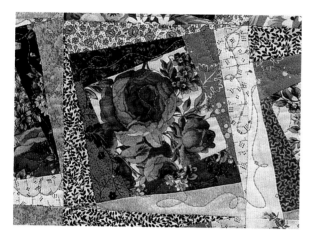

Pieced flower block from "A Field of Blue." For a full view of this quilt, see page 67.

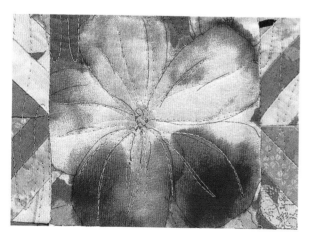

Flower block from "Jasmine." For a full view of this quilt, see page 81.

The Blender Block

Just as the name says, a Blender block blends color from one area of the quilt to another, using colors from each area to form a visual "bridge." Blender blocks are usually simple in their pieced design, allowing the fabrics to make the transition.

The instructions for each project tell you how to make the Blender blocks and how many you'll need.

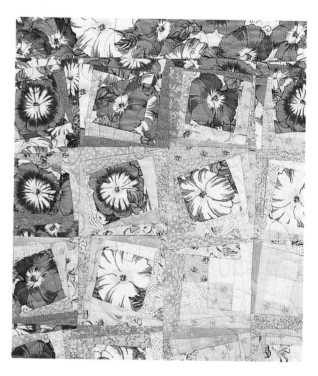

Blender blocks help make the transition from dark to light in "Bouquets for Brooklynn." For a full view of this quilt, see page 63.

You may need more than one variety or colorway of Blender block to transition smoothly between the areas of color within your quilt, especially if the quilt includes large areas of very different colors. Sometimes two—or even three—rows (and types) of Blender blocks are needed to make a smooth

transition between the colors. This is the case in "Tropical Tulips" (detail below), in which a variety of Blender blocks create the transition between several lively colors.

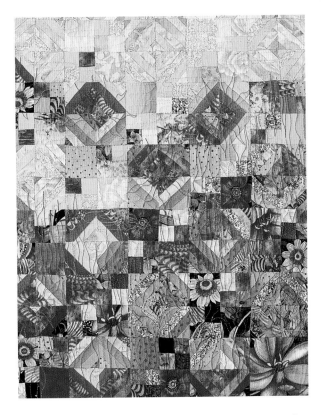

Fabrics blend from yellow to orange in "Tropical Tulips." For a full view of this quilt, see page 76.

The fun part of making these simple, scrappy blocks is that you can use dozens and dozens of fabrics to make each block different. Even though my quilts may have many blocks, I *never* get bored piecing them. Often each newly completed block becomes my newest favorite!

I love working with dozens—even hundreds—of different fabrics, and Blender blocks give me the perfect opportunity to do just that. When I'm creating a Scatter Garden quilt, I typically cut and piece a small group of Blender blocks at a time. I put them up on my design wall to see if the colors are working and if the blocks are accomplishing the color blend I want. I can also see if certain fabrics work

so well (and look so fantastic!) that I want to include more of them.

Working this way keeps me from getting bored with the process. I have lots more fun stitching my quilt if I switch from one task to another; that is, from cutting, to stitching, to admiring how the blocks come together on the wall!

The Background Block

Scrappy Background blocks create a lively backdrop for your quilt—a backdrop that helps accentuate the fussy-cut or appliquéd flowers. Often the Background blocks are constructed just like the Blender blocks in a project, except they use a more subtle range of fabrics that don't change from one color to another.

Sometimes Background blocks feature different configurations of fabrics and shapes. Some blocks may be as simple as a square cut from a single fabric (see detail below). The various options all combine to make a fantastic background for your Scatter Garden quilt.

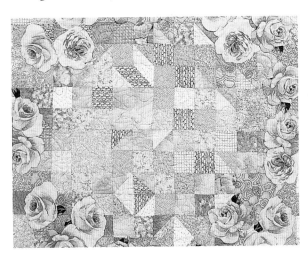

Background blocks in "A Garden Wreath." For a full view of this quilt, see page 84.

THE "P" WORD

You guessed it . . . press!

Quilters often ask me how I keep the pressing directions straight when working with the various blocks and pieces. My answer is very simple—I don't! Because I often rotate and move the blocks in my quilts until I get them in just the right spot, it is nearly impossible to keep track of the pressing—that is, unless I become totally paranoid about it, which I'd rather not!

Instead, I press as I make each block and, when it's done, I press the block flat. I also press the seams between the blocks in alternating directions when I assemble the rows. I don't worry about the seams that come together where the blocks join. Sometimes they mesh perfectly and other times they don't. Either way works just fine in the end.

To compensate and to flatten the seams, I machine quilt very heavily, going back and forth over the seams. Try it. When you see your amazing Scatter Garden quilt on the wall or on a bed, I don't think you'll be able to tell what the seams are doing!

So relax. Have fun piecing and playing with your blocks. Don't worry about the pressing direction of the seams. It's OK this way—trust me!

The Garden Map

Now it's time to put all the pieces together—the Flower blocks, the Blender blocks, and the Background blocks. To help you, I've included a garden map with each project. This basic diagram shows you where and how to position each type of block to make a quilt like the one pictured.

Remember that the garden map is just a guide. It's *your* Scatter Garden quilt and you can make any changes you like. Just as you may decide you'd prefer a few more zinnias and not as many cosmos in your flower garden as you'd planned, you may decide you want a few more Blender blocks and not as many Background blocks in your quilt.

Garden Map

Blender blocks

Flower blocks

Begin by putting the blocks up on your design wall, either using the garden map as a guide or by following your own arrangement. If you don't have room to put up the entire quilt, put up a quarter or a half at a time.

MAKING A DESIGN WALL

If you're handy with tools, or someone in your family is, it's easy to construct a design wall. I used two large pieces of Celotex ceiling tile, or white building board, about 1" thick. Check at your local building supply store for information on these or other suitable materials.

Cut a piece of heavyweight flannel about 3" larger than the foundation board on all sides. You can piece the flannel if necessary or cover the sections separately. Pull the edge of the flannel to the back of the board and secure in place with heavy-duty tape. Then simply screw the covered panel (or panels) to the wall.

For a simpler, less permanent design wall, use a piece of batting or heavy flannel that you can tape or pin to your wall and take down when necessary. There are also commercially made design walls—some with a preprinted grid—available through a variety of sources. Check at your local quilt shop for more information.

Next comes my very favorite part—moving the blocks around until I get just the right arrangement. I love seeing the different patterns emerge as I change and rotate the blocks. You'll most likely have your own preference for how to position the blocks, and this is what will make your Scatter Garden quilt unique. Even if you and a friend were to make the same quilt from the same fabrics, the way you each construct and arrange your blocks would lead to different, but equally delightful, results.

To show you just how much difference the fabric choices can make, each project quilt in this book includes "Another Look," a second version of the same basic design. Some of these alternatives use the same garden map, with the only difference being the color or theme of the fabrics. Others vary slightly in size or have other minor changes in the layout. I hope these variations inspire you to make *your* quilt a truly one-of-a-kind creation.

Each of the Scatter Garden quilts in this book has its own personality and plan. Some, such as "Rambling Roses" (page 16) and "Undersea Garden" (page 40), are designed to be flexible so you can have fun moving and interchanging the blocks. Other quilts, such as "Garden Stars" (page 46) and "Hot Summer Sun" (page 24), rely a little more on the garden map for the overall quilt design. Whichever quilt you choose to make, enjoy putting it together to show off *your* fantastic floral fabric.

Now that you've made your plans and picked up some "gardening tips," you're ready to plant your Scatter Garden quilt!

Rambling Roses

"Dramatic" definitely describes this Scatter Garden quilt! I don't usually work with red and black, but when I found this rose-covered focal fabric, I knew I'd be making a red-and-black quilt. The gorgeous red roses remind me of an abundant cottage garden blooming with fragrant blossoms.

CHOOSING YOUR FABRICS

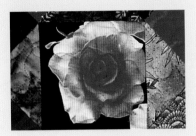

Choose a focal fabric with flowers that measure about 4" square and don't all overlap. As with all the quilts in this book, the amount of focal fabric you need will depend on the print. Don't scrimp on the yardage; you can always add what's left to your stash.

For the coordinating floral, select a smaller, allover print that complements the focal fabric. Keep the intensity of the fabrics the same, either all bold and intense or all soft and subtle. Look for some green prints with leaf motifs and other prints that include touches of the background color of the focal print. The greater variety of prints you use, the livelier your quilt will be.

Materials

Yardage requirements are based on 42"-wide fabric.

- 2½ yards of large-scale floral print for fussy-cut block centers★
- 4⅓ yards of coordinating small-scale floral print for blocks, outer border, and binding
- 1¾ yards *total* of assorted green prints for blocks
- 1⅜ yards *total* of assorted black and dark gray prints for blocks
- 1⅜ yards *total* of assorted red and dark pink prints for blocks
- ⅓ yard of pink print for inner border
- 7½ yards of fabric for backing
- 89" x 105" piece of batting
- 4½" acrylic square ruler

★*Amount will vary depending on the print.*

You're the Designer!

I've given you the number of Flower blocks and various Blender blocks that I used, and the cutting instructions reflect these numbers. However, you may want to make your quilt differently. It's up to you. Don't be afraid to experiment!

Instead of cutting all of the pieces at once, you may prefer to cut and sew as you go. Try cutting enough pieces to make about a quarter of the blocks at a time. As you complete each group, put them on your design wall and stand back to take a look. You may discover that you love some of the color and print combinations but don't like others. As you piece the next group of blocks, eliminate combinations that don't work as well and make more of those you love.

Cutting

These cutting instructions yield enough pieces to make the entire quilt. Cut all strips across the width of the fabric. Refer to "Fussy Cutting" on page 9 as needed.

From the assorted green prints, cut a total of:

160 squares, 3¾" x 3¾"; cut once diagonally to make 320 half-square triangles

From the large-scale floral print, fussy cut:

48 flower squares, 4½" x 4½"

From the assorted black and dark gray prints, cut a total of:

54 squares, 5⅜" x 5⅜"; cut twice diagonally to make 216 quarter-square triangles

From the assorted red and dark pink prints, cut a total of:

54 squares, 5⅜" x 5⅜"; cut twice diagonally to make 216 quarter-square triangles

Designing the Quilt

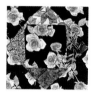

- To create a blended effect, position Blender blocks along the sides of the quilt so the small-scale print triangles are nearest to the matching-print border.

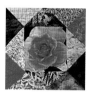

- Leaf prints add a touch of garden greenery to the roses.

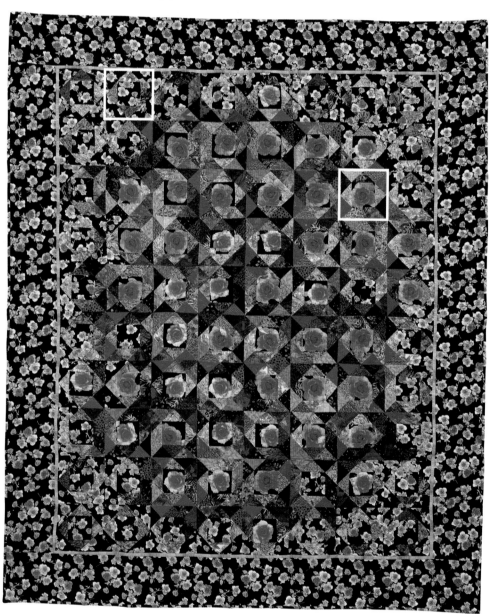

Finished quilt size: 81½" x 97½" • **Finished block size:** 8"

From the small-scale floral print, cut:

32 squares, 4½" x 4½"

52 squares, 5" x 5"; cut once diagonally to make 104 half-square triangles

9 strips, 8½" x 42"

10 binding strips, 2½" x 42"

From the pink print, cut:

8 strips, 1" x 42"

STORING FABRIC

Small clear plastic boxes are essential to me when I make a quilt with lots of different-colored pieces. I keep the assorted prints of each color in a separate box. I don't need to waste time keeping track of the various fabrics, and I can easily see which ones I have left. I can also see if I'm running out of a favorite print and need to cut more!

Making the Blocks

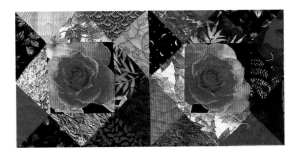

Now you're ready for the fun part: putting the pieces together to make an assortment of colorful, unique blocks for your Scatter Garden quilt. Mix up the green, the black and dark gray, and the red and dark pink triangles in each block to create a scrappy look. Square up each completed block to 8½".

Flower Blocks

You need 39 pieced Flower blocks for this quilt.

1. Sew a green triangle to opposite sides of a fussy-cut floral square as shown; press. Sew a green triangle to the remaining sides of the square; press. Square up the unit to 6¼". Make 39.

Make 39.

2. Sew a black or dark gray triangle and a red or dark pink triangle together as shown; press. Make 156 scrappy combinations.

Make 156.

3. Sew a triangle unit from step 2 to opposite sides of a unit from step 1 as shown; press. Repeat on the remaining sides; press. Make 39 blocks.

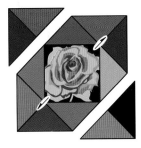
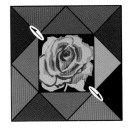

Flower Block
Make 39.

19

Blender Blocks

 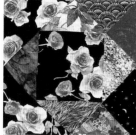

You need a total of 41 Blender blocks in four variations for this quilt: 14 of Block A, 15 of Block B, 9 of Block C, and 3 of Block D. Each variation uses a different combination of fabrics. You can make the same number of each variation as I have, or make more or fewer of any one variety.

Blender Block A

1. Sew a green triangle to opposite sides of a small-scale floral square as shown; press. Sew a green triangle to the remaining sides of the square; press. Square up the unit to 6¼". Make 14.

Make 14.

2. Sew a small-scale floral triangle to opposite sides of each unit from step 1; press. Repeat for the remaining sides; press. Make 14 and label them Block A.

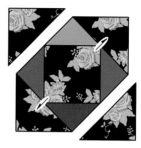 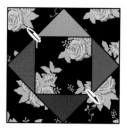

Block A
Make 14.

Blender Block B

1. Repeat step 1 of "Blender Block A" to make 15 units.

2. Sew a black or dark gray triangle and a red or dark pink triangle together as shown; press. Make 30 scrappy combinations.

Make 30.

3. Sew a triangle unit from step 2 and a small-scale floral triangle to opposite sides of a unit from step 1 as shown; press. Sew a triangle unit and small-scale floral triangle to the remaining sides of the unit; press. Make 15 and label them Block B.

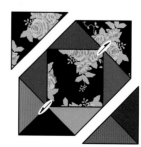 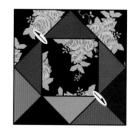

Block B
Make 15.

Blender Block C

Repeat the steps for making Blender Block B, substituting a fussy-cut floral square for the block center. (You'll need 18 triangle units.) Make nine and label them Block C.

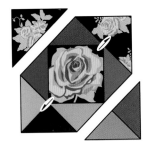
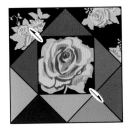

Block C
Make 9.

Blender Block D

Repeat the steps for making Flower Blocks (page 19), substituting a small-scale floral square for the block center. (You'll need 12 triangle units.) Make three and label them Block D.

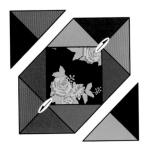
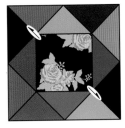

Block D
Make 3.

Putting It Together

Refer to the photo on page 18 and the garden map above right for guidance in placing the Flower blocks and various Blender blocks. You may wish to move the Blender blocks around until you find the perfect arrangement, just as you would move flowers in your real-life garden.

A	A	B	B	C	A	A	A

A	B					C	A

B							B
A	C						C
B						D	C
B	D						B
C	C						B
B							B
A	B				D	C	A
A	A	B	B	C	B	A	A

Garden Map

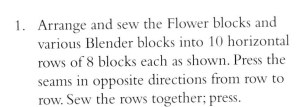

Blender blocks

Flower blocks

1. Arrange and sew the Flower blocks and various Blender blocks into 10 horizontal rows of 8 blocks each as shown. Press the seams in opposite directions from row to row. Sew the rows together; press.

2. Refer to "Adding Borders" on page 89 to piece, trim, and sew the 1"-wide pink strips to the sides, top, and bottom of the quilt. Press the seams toward the border. Repeat to piece, trim, and sew the 8½"-wide small-scale floral strips to the quilt. Press the seams toward the outer border.

Finishing Your Quilt

Refer to "General Instructions," beginning on page 89, for specific instructions for each of the following finishing steps.

1. Layer the quilt top with batting and backing; baste.

2. Quilt around the outside of the fussy-cut flowers, about ⅛" from the edges. Quilt inside the flowers, following the outline of the petals. Quilt the rest of the quilt in a favorite allover pattern.

3. Use the 2½"-wide small-scale floral strips to bind the quilt edges.

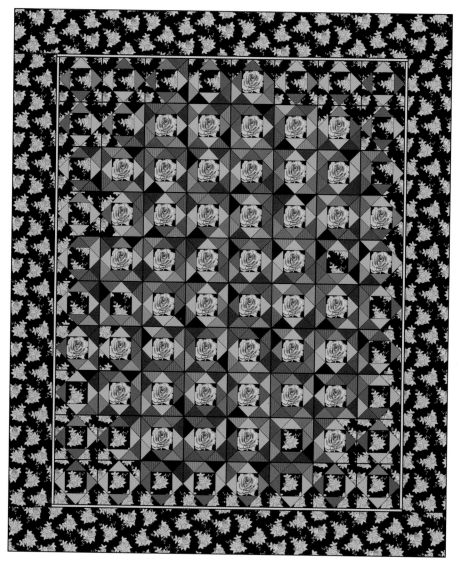

Quilt Plan

Another Look

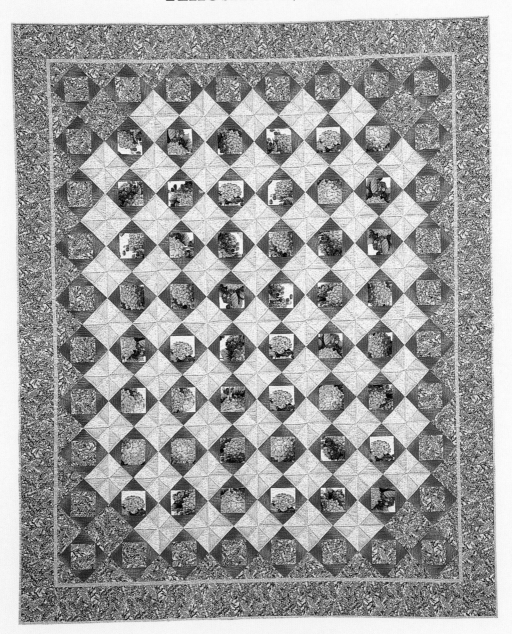

SWEET HYDRANGEAS

The look and feel of your garden depends entirely upon the seeds you scatter. Its color can change from bold and beautiful to soft and sweet, just as in this variation of "Rambling Roses." I've used the same blocks, but the effect couldn't be more different. Instead of dark and dramatic, "Sweet Hydrangeas" creates a demure, traditional look. The Flower blocks take on a different look because I fussy cut them from different areas of the large-scale floral print. The small triangles in each block are matched, rather than scrappy as in "Rambling Roses."

Hot Summer Sun

Hot summer colors and giant, dramatic flowers make this twin-size
quilt a garden sizzler. It's the perfect choice for any of those irresistible,
very-large-scale flower prints you don't quite know what to do with.
There's plenty of room to have fun in choosing and mixing the
colors to create your very own red-hot Scatter Garden quilt!

CHOOSING YOUR FABRIC

This is a great quilt for combining traditional quilter's cottons with some of the gorgeous bark cloth or home-decorator fabrics available today. You'll need a focal print with flowers that measure about 8" for fussy cutting, and many home-decorator fabrics feature fabulous large-scale motifs. Include a little of this heavier-weight fabric in the Blender blocks for balance. You'll love the dramatic results!

Materials

Yardage requirements are based on 42"-wide fabric.

- 2½ yards of large-scale floral print for fussy-cut flowers, blocks, and pieced border★
- 2¾ yards of orange paisley for blocks, pieced border, outer border, and binding
- 2⅛ yards of yellow print for blocks and pieced border
- ⅞ yard *total* of assorted black, orange, hot pink, and red prints for blocks and pieced border
- ½ yard of orange print for blocks
- ⅓ yard of red print for blocks
- 4¼ yards of fabric for backing
- 76" x 92" piece of batting
- 8½" acrylic square ruler

★*Amount will vary depending on the print.*

Cutting

Cut all strips across the width of the fabric. Refer to "Fussy Cutting" on page 9 as needed.

From the yellow print, cut:
28 strips, 2½" x 42"; crosscut into 440 squares, 2½" x 2½"

From the large-scale floral print, fussy cut:
22 squares, 8½" x 8½"

From the remaining large-scale floral print, cut:
18 strips, 2½" x 42"; crosscut into 142 pieces, 2½" x 4½"

From the orange print, cut:
5 strips, 2⅞" x 42"; crosscut into 62 squares, 2⅞" x 2⅞". Cut once diagonally to make 124 half-square triangles.

From the red print, cut:
3 strips, 3⅜" x 42"; crosscut into 31 squares, 3⅜" x 3⅜"

From the orange paisley, cut:
3 strips, 8½" x 42"; crosscut into 10 squares, 8½" x 8½"

4 strips, 2½" x 42"; crosscut into 14 pieces, 2½" x 8½", and 4 squares, 2½" x 2½"

8 strips, 4½" x 42"

8 binding strips, 2½" x 42"

From the assorted black, orange, hot pink, and red prints, cut a *total* of:
160 squares, 2½" x 2½"

Designing the Quilt

- Flower petals in the red print add interest to the large flower blocks.

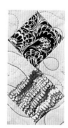

- The pieced border extends the outside row of flowers to complete their design.

- Assorted scrappy squares blend with the flower blocks, while the red squares balance the dark flower centers.

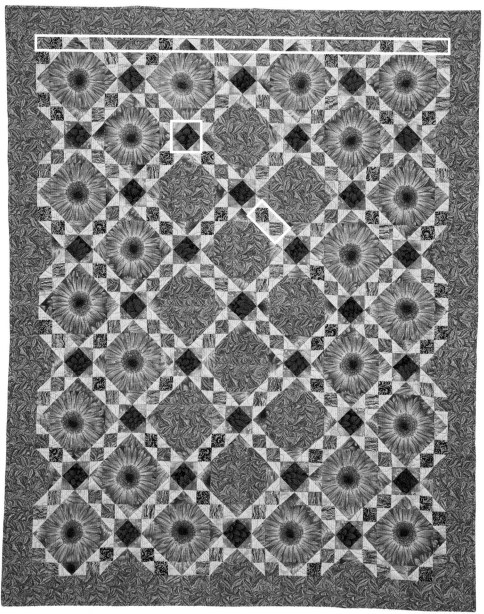

Finished quilt size: 68" x 84" • **Finished block size:** 8"

Flower Blocks

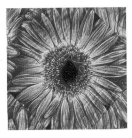

You need 22 Flower blocks for this quilt. Draw a diagonal line on the wrong side of four yellow squares. With right sides together, position a marked square on each corner of a fussy-cut floral square as shown. Sew on the marked lines; trim the seam allowance on the small squares to ¼", and press. Make 22 blocks.

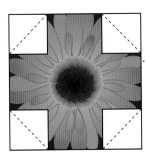

Make 22.

Blender Blocks

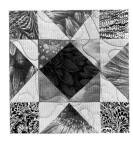

You need 31 Blender blocks for this quilt.

1. Sew an orange triangle to opposite sides of a red square as shown; press. Sew an orange triangle to the remaining two sides; press. Square up the unit to 4½". Make 31.

Make 31.

2. Draw a diagonal line on the wrong side of two yellow squares. With right sides together, position a square on one end of a 2½" x 4½" floral piece as shown. Stitch on the marked line; trim the seam allowance on the square to ¼", and press. Repeat to sew the other marked square to the opposite end; trim and press. Make 124.

Make 124.

3. Arrange a unit from step 1, four units from step 2, and four 2½" assorted print squares into three rows as shown. Sew the units together into rows, and then sew the rows together to complete the block. Make 31 blocks.

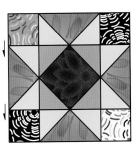

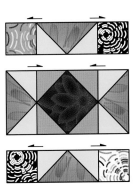

Make 31.

27

Background Blocks

You need 10 Background blocks for this quilt. Draw a diagonal line on the wrong side of four yellow squares. With right sides together, position a marked square on each corner of an 8½" orange paisley square as shown. Sew on the marked lines; trim the seam allowance on the small squares to ¼" and press. Make 10 blocks.

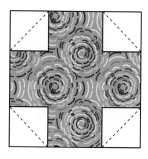 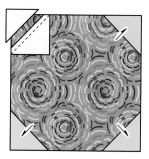

Make 10.

Putting It Together

Refer to the photo on page 26 and the garden map above right for guidance as needed.

1. Arrange and sew the Flower blocks, the Blender blocks, and the Background blocks in nine horizontal rows of seven blocks each as shown. Press the seams in opposite directions from row to row. Sew the rows together; press.

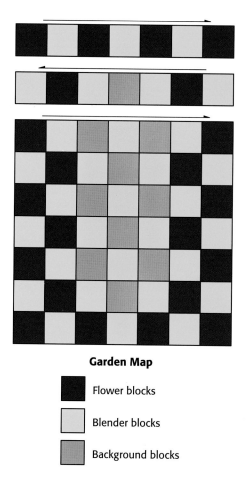

Garden Map

■ Flower blocks

□ Blender blocks

▨ Background blocks

2. Draw a diagonal line on the wrong side of two yellow squares. With right sides together, position a square on one end of a 2½" x 4½" floral piece as shown. Stitch on the drawn line; trim the seam allowance on the square to ¼", and press. Repeat to sew the other marked square to the opposite end; trim and press. Make 18.

Make 18.

3. Sew a 2½" assorted print square to each end of a unit from step 2; press. Make 18 units and label them Unit A.

Unit A
Make 18.

4. Draw a diagonal line on the wrong side of each remaining yellow square. With right sides together, position a marked square on each end of a 2½" x 8½" paisley piece as shown. Stitch on the drawn line; trim the seam allowance on the squares to ¼" and press. Make 14 units and label them Unit B.

Unit B
Make 18.

5. Arrange and sew together five A units from step 3 and four B units from step 4 as shown below; press. Make two pieced side border units.

6. Referring to the photo and the garden map, sew the units from step 5 to the sides of the quilt. Press the seams toward the pieced border units.

7. Arrange and sew together four A units from step 3 and three B units from step 4 as shown; press. Sew a 2½" orange paisley square to each end as shown; press. Make two pieced top and bottom border units.

8. Referring to the photo and the garden map, sew the units from step 7 to the top and bottom of the quilt. Press the seams toward the pieced border units.

9. Refer to "Adding Borders" on page 89 to piece, trim, and sew the 4½"-wide orange paisley borders to the sides, top, and bottom of the quilt. Press the seams toward the border.

Side Borders
Make 2.

Top and Bottom Borders
Make 2.

29

Finishing Your Quilt

Refer to "General Instructions," beginning on page 89, for specific instructions for each of the following finishing steps.

1. Layer the quilt top with batting and backing; baste.

2. Quilt around the outside of the fussy-cut flowers, about ⅛" from the edge. Quilt inside the flowers following the outline of the petals. Quilt the rest of the quilt in a favorite allover pattern.

3. Use the 2½"-wide orange paisley strips to bind the quilt edges.

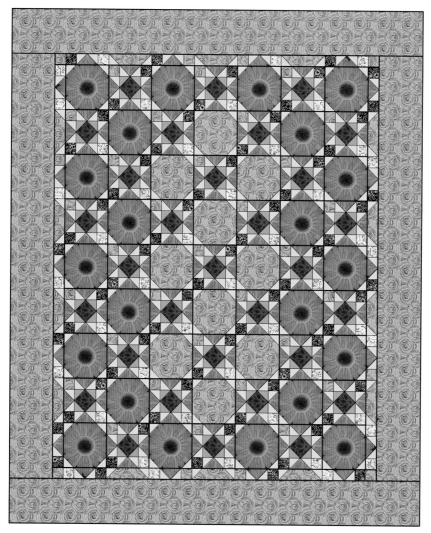

Quilt Plan

Another Look

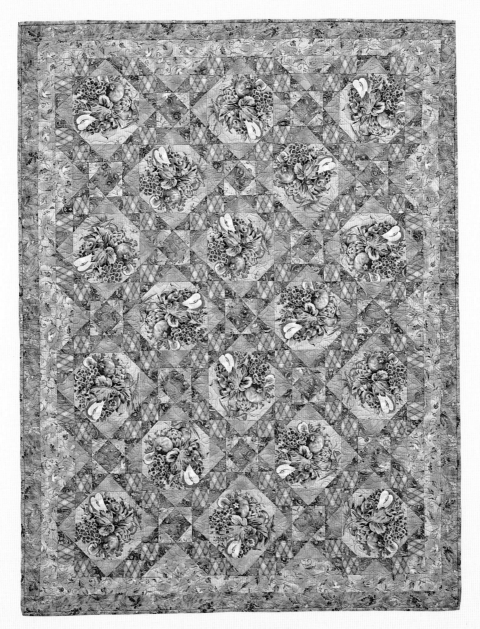

TUSCANY GARDEN

What an amazing difference fabric can make! This Scatter Garden quilt is as soft and mellow as "Hot Summer Sun" is brilliant and bold. The Flower blocks actually include a harvest basket of fruit in subdued colors that blend with the rest of the quilt.

I made this quilt in seven rows of five blocks each—slightly smaller than the original. If you decide to reduce or increase the number of blocks (and the overall size of the quilt), be sure to do so in two-block increments so that the overall pattern remains the same.

Lost in the Garden

This quilt is like a garden maze, with dozens of colors and prints twisting and turning to create its lively pattern of blooming flowers. Purple and rose-colored pansies are fussy cut for the center of the quarter-circle blocks, and you can arrange and rearrange the circles to make your own unique design.
Don't worry—piecing the curves is easy as a summer breeze!

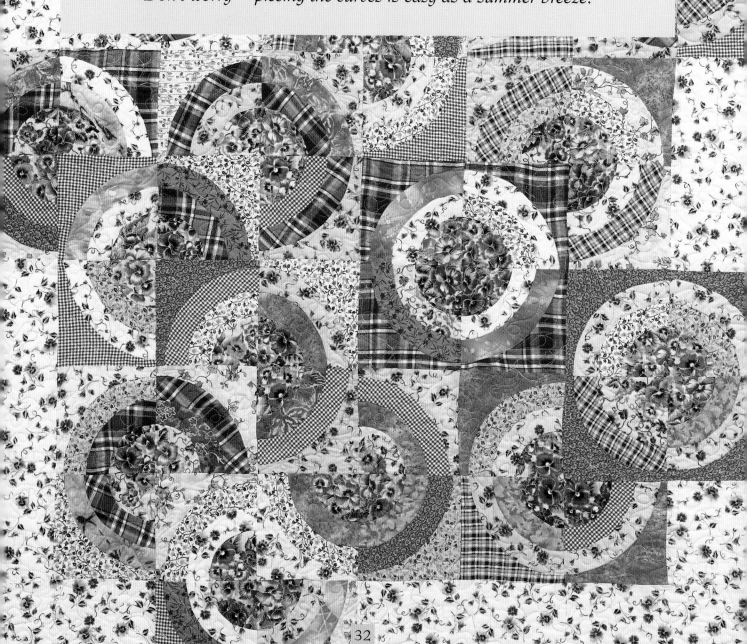

CHOOSING YOUR FABRICS

Look for a somewhat small-scale floral print so you can capture a group of flowers (rather than a single bloom) when you fussy cut piece A. In fact, make the template for this piece and take it with you when you shop for fabric. Position the template on potential fabrics to help you preview how the print will look when you fussy cut the pieces. Choose companion prints in a variety of scales, and—for the unexpected—add plaids and checks to the mix.

You're the Designer!

Don't you just love the blocks in this quilt? Instead of cutting all of your pieces at once, consider cutting enough pieces to make about one quarter of the blocks at a time. Vary the scale of the fabric prints within each block for added interest. As you work, you may decide you prefer certain fabrics or fabric combinations to others, and you can adjust the balance of your cutting accordingly. If you wish, cut a few more pieces than you'll need so you have extras to play with.

Materials

Yardage requirements are based on 42"-wide fabric.

- 2 yards of medium-scale floral print for fussy-cut block centers and inner border★
- 4 yards *total* of assorted pink, purple, cream, white, and green floral prints and coordinating plaids and checks for blocks
- ⅔ yard of white floral print for background squares and strips
- ⅝ yard of lavender print for outer border
- ⅝ yard of lavender check for binding
- 3⅝ yards of fabric for backing
- 64" x 76" piece of batting
- Template plastic★★

★*Amount will vary depending on the print.*

★★*You can use template plastic and the patterns on pages 38 and 39 to make your own templates, or, like me, you can purchase templates designed by Nancy Elliott MacDonald. You may order them through her Web site, www.nancymac.com, or by calling 916-966-5317.*

Cutting

These cutting instructions yield enough pieces to make the entire quilt. Cut all strips across the width of the fabric. See "Making the Blocks" on page 35 for instructions about cutting pattern pieces A–D.

From the white floral print, cut:
 4 strips, 6½" x 42"; crosscut into:
 2 squares, 6½" x 6½"
 3 strips, 6½" x 12½"
 1 strip, 6½" x 18½"
 2 strips, 6½" x 24½"

From the medium-scale floral print, cut:
 6 strips, 2½" x 42"

From the lavender print, cut
 7 strips, 2½" x 42"

From the lavender check, cut:
 7 binding strips, 2½" x 42"

Designing the Quilt

- For added interest, position some of the units so that the D pieces match, creating a complete circle.

- To make your blocks more vibrant and exciting, vary the scale of the prints within each block.

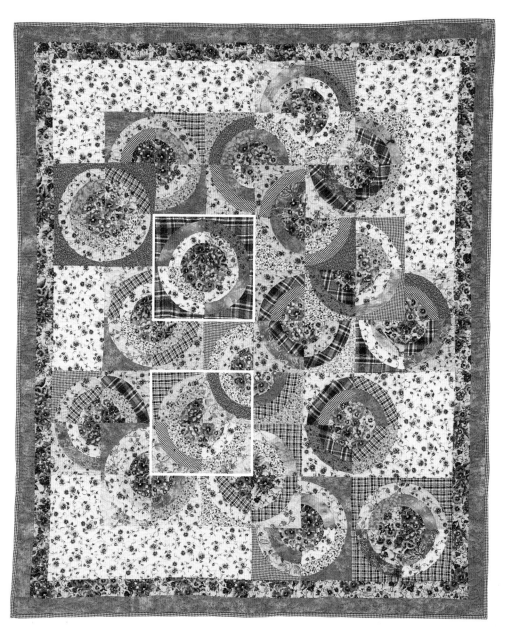

Finished quilt size: 56½" x 68½" • **Finished block size:** 6"

Making the Blocks

You'll need 61 Blender blocks. Make the blocks as scrappy as you'd like, mixing florals, checks, and plaids. Refer to "Fussy Cutting" on page 9 as needed. Square up each completed block to 6½".

1. Make plastic templates for pieces A–D by tracing the patterns on pages 38 and 39. If you prefer to use ready-made templates, see page 33 for ordering information.

2. Select a group of flowers to fussy cut from the medium-scale floral print. Position template A over the flowers you have chosen and cut around the template with a rotary cutter. Cut 61 A pieces.

3. Cut 61 *each* of pieces B, C, and D from the assorted pink, purple, cream, white, and green floral prints and the assorted coordinating checks and plaids.

4. With right sides together, place a B piece on an A piece as shown. Pin at both ends.

5. Ease the raw, curved edges and stitch the pieces together with a ¼"-wide seam as shown. If you wish, place a pin at the midpoint to secure the edges as you stitch. Flip piece B open and press lightly on the right side with a dry iron. Do not use steam or press heavily as this may stretch the bias edge. Make 61.

Make 61.

6. Sew a C piece to each unit from step 5 as shown; press. Add a piece D to complete the block; press. Make 61 blocks.

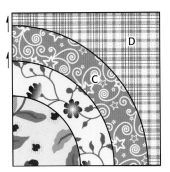

Make 61.

Putting It Together

Refer to the photo on page 34 and the garden map below for guidance in placing the Blender blocks. You may wish to move these blocks around until you find the perfect arrangement, just as you would move flowers in your real-life garden.

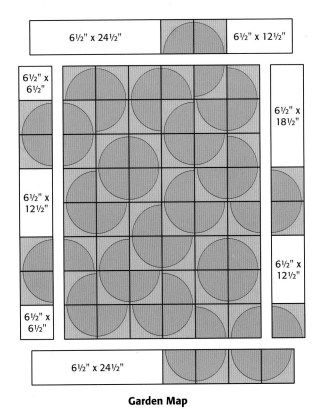

Garden Map

Blender blocks

1. Arrange the Blender blocks, the white floral squares, and the white floral strips into sections as shown in the garden map on page 35.

2. Sew the center Blender blocks into eight horizontal rows of six blocks each. Press the seams in opposite directions from row to row. Sew the rows together; press.

3. Sew the remaining Blender blocks and the white floral squares and strips into four units as shown below; press. Sew the side units to the left and right sides of the quilt center. Press the seams toward the side units. Sew the top and bottom units to the top and bottom of the quilt center; press.

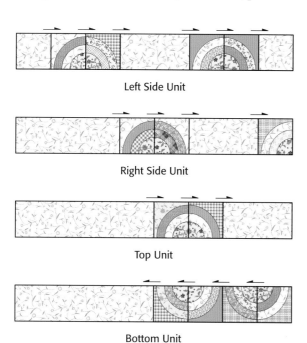

Left Side Unit

Right Side Unit

Top Unit

Bottom Unit

4. Refer to "Adding Borders" on page 89 to piece, trim, and sew the medium-scale floral strips to the sides, top, and bottom of the quilt. Press the seams toward the border. Repeat to piece, trim, and sew the lavender strips to the quilt. Press the seams toward the outer border.

Finishing Your Quilt

Refer to "General Instructions," beginning on page 89, for specific instructions for each of the following finishing steps.

1. Layer the quilt top with batting and backing; baste.

2. Quilt heavily in a favorite allover pattern.

3. Use the lavender check strips to bind the quilt edges.

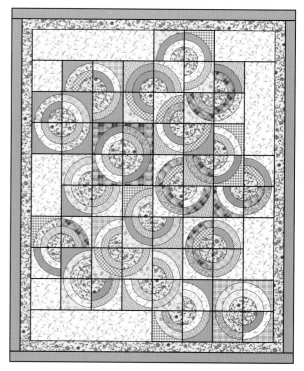

Quilt Plan

Another Look

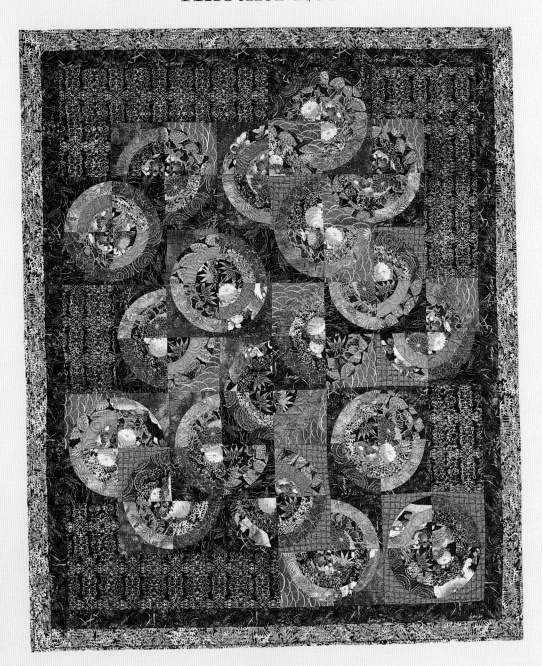

EXOTICA

Could this exotic variation look any more different from the original? I don't think so! "Exotica" uses the same garden map as "Lost in the Garden." The only difference comes in the choice of fabric. Dark, dramatic Asian-influenced prints and other richly textured fabrics combine here to create a fantastic and mysterious Scatter Garden quilt. As a finishing touch, gold metallic quilting echoes the metallic accents in some of the fabrics.

Piecing Patterns

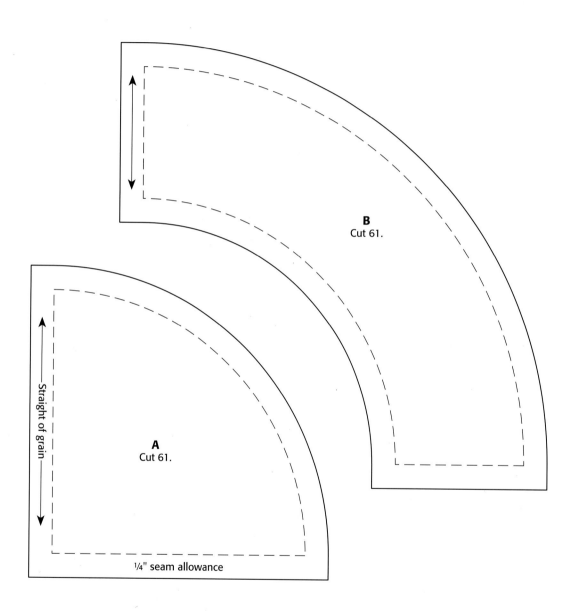

B
Cut 61.

A
Cut 61.

Straight of grain

¼" seam allowance

Piecing Patterns

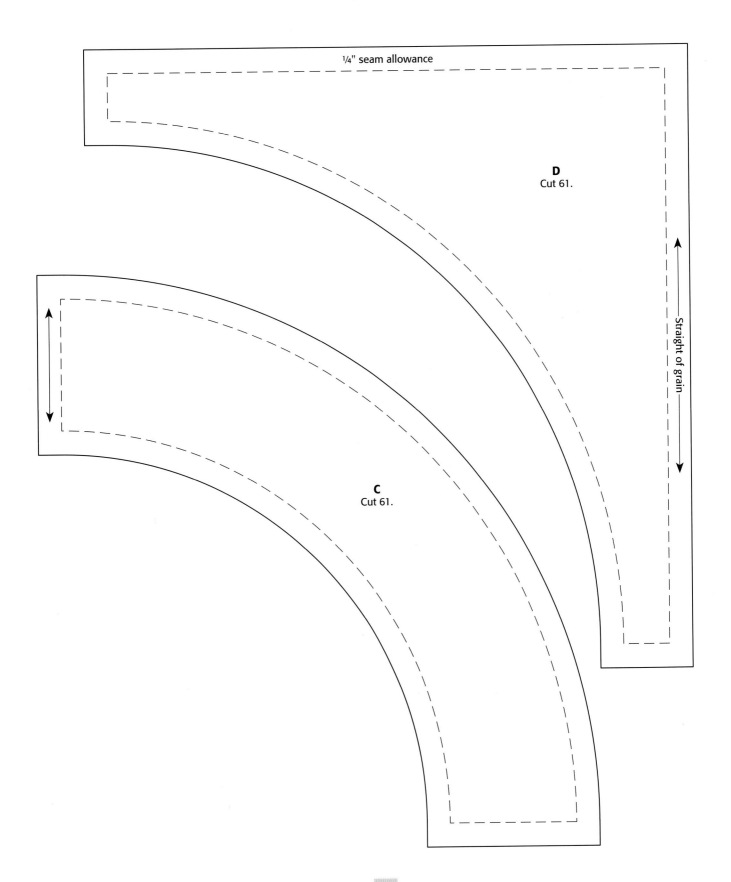

¼" seam allowance

D
Cut 61.

Straight of grain

C
Cut 61.

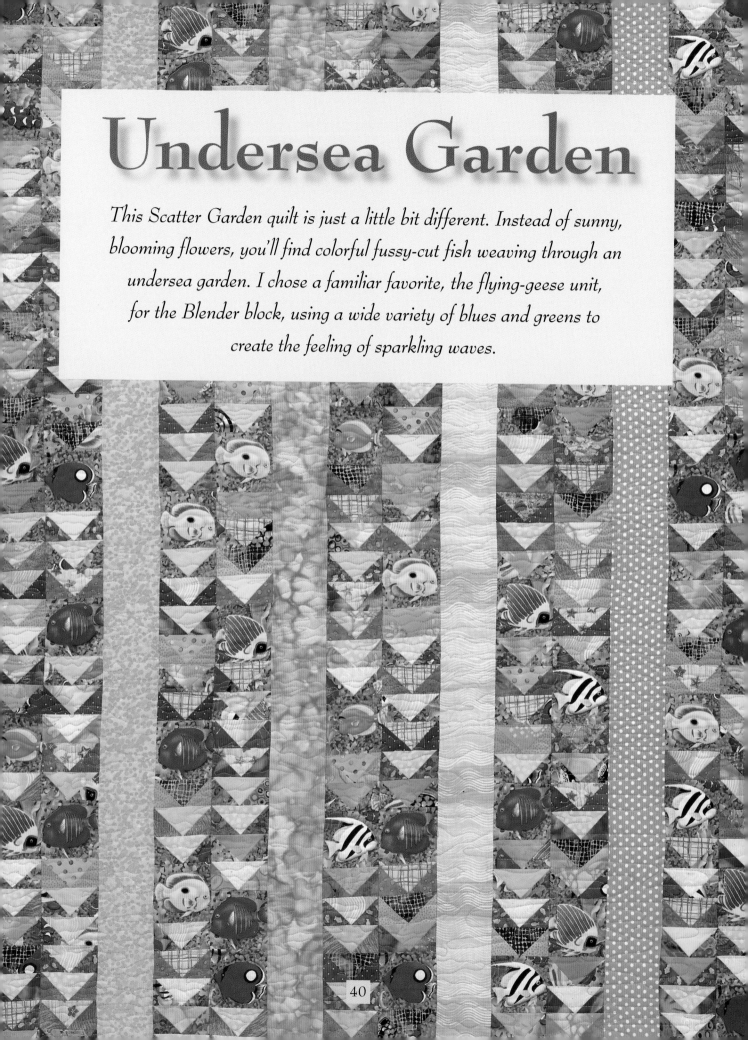

Undersea Garden

This Scatter Garden quilt is just a little bit different. Instead of sunny, blooming flowers, you'll find colorful fussy-cut fish weaving through an undersea garden. I chose a familiar favorite, the flying-geese unit, for the Blender block, using a wide variety of blues and greens to create the feeling of sparkling waves.

CHOOSING YOUR FABRICS

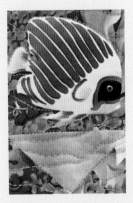

Look for a focal fabric—or several such fabrics—featuring fish or other undersea creatures that measure about 3" square. My fabric included fish in a variety of colors and shapes, and I fussy cut as many different motifs as possible for this quilt. Then I added as many shades and prints of greens and blues as I could find for the flying-geese units.

Materials

Yardage requirements are based on 42"-wide fabric.

- 2 yards of fish print for fussy-cut fish and blocks★
- 1¾ yards *total* of assorted green prints for blocks
- 1¾ yards *total* of assorted blue prints for blocks
- ⅓ yard *each* of 3 different blue prints for sashing
- ⅓ yard *each* of 3 different green prints for sashing
- ⅞ yard of fabric for facing
- 3¼ yards of fabric for backing
- 56" x 71" piece of batting
- 3½" acrylic square ruler

★*Amount will vary depending on the print.*

You're the Designer!

The cutting instructions include the precise number of pieces you'll need to make the quilt as shown on page 42. However, this is such a scrappy quilt that you might want to cut a few more pieces than you need so that you'll have extras to play with. When you've finished making all the blocks for this quilt, set the left-over pieces aside for another project. I paired matching blue or fish-fabric squares with each green piece to make the Blender blocks. For a scrappier look, try a different print on each end of the green rectangle.

Cutting

Cut all strips across the width of the fabric. Refer to "Fussy Cutting" on page 9 as needed.

From the fish print fabric, fussy cut:
53 fish squares, 3½" x 3½"

From the remaining fish print and the assorted blue prints, cut a *total* of:
628 squares, 2" x 2", in matching pairs

From the assorted green prints, cut a *total* of:
314 pieces, 2" x 3½"

From *each* of the different blue prints and green prints for sashing, cut:
2 strips, 3½" x 42" (12 total)

From the facing fabric, cut:
6 strips, 4½" x 42"

Designing the Quilt

• Cut some of the flying-geese squares from the background of the fish fabric to create a little unity between the Blender blocks and the Fish blocks.

• I scattered a few rectangles of yellow print throughout my Blender blocks to liven up the cool aquatic greens and blues.

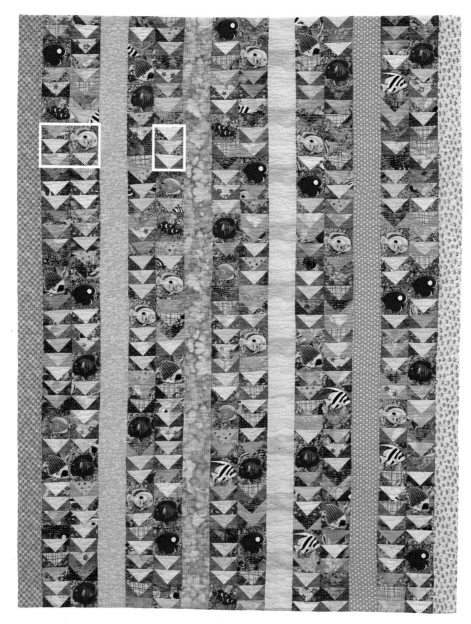

Finished quilt size: 48" x 63"
Finished block sizes: 3" x 1½" (Blender blocks) and 3" x 3" (Fish blocks)

Blender Blocks

You need 314 Blender blocks for this quilt.

Draw a diagonal line on the wrong side of two matching blue or 2" fish-print squares. With right sides together, position a square on one end of a 2" x 3½" green-print rectangle. Stitch on the marked line; trim the seam allowance on the square to ¼" and press. Repeat to sew the other marked square to the opposite end; trim and press. Make 314.

Make 314.

FAST FORWARD

You can piece these Blender blocks even more quickly by chain-piecing them. Sew one square to one rectangle on the marked diagonal line, and then feed another square-and-rectangle unit under the presser foot without cutting the thread in between. When you have chained 20 or 30 units, stop sewing, cut the units apart, trim, and press. Repeat to add the square on the other end of the unit. Continue piecing in groups of 20 to 30 units until you have made the number of Blender blocks you need for your quilt.

Putting It Together

Refer to the photo on page 42 and the garden map below for guidance in placing the Fish blocks and various Blender blocks. You may wish to experiment by moving the blocks within the vertical rows until you find the perfect arrangement.

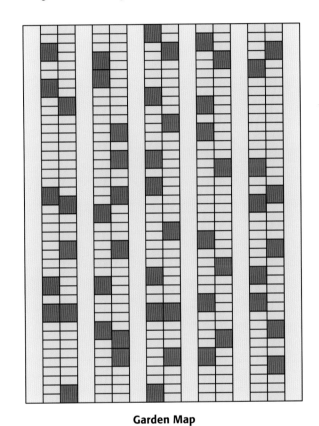

Garden Map

☐ Blender blocks

■ Fish blocks

1. Arrange and sew the Fish blocks and Blender blocks together into 10 vertical rows. Each row should measure 63½". (You may need to take in or let out a seam here or there to equal this measurement.) Sew the rows together in pairs; press.

2. Sew the matching strips of each sashing fabric together end to end to make one long strip of each fabric; press. Trim each strip to 63½".

3. Position and sew a sashing strip between each row from step 1. Press the seams toward the sashing strips. Sew a remaining strip to the sides of the quilt; press.

Finishing Your Quilt

Refer to "General Instructions," beginning on page 89, for specific instructions for each of the following finishing steps.

1. Layer the quilt top with batting and backing; baste.

2. Quilt around the outside edges of the fish motifs. Quilt the rest of the quilt heavily in an overall horizontal wavy pattern to resemble water.

3. Use the 4½"-wide strips to add facings to the quilt edges.

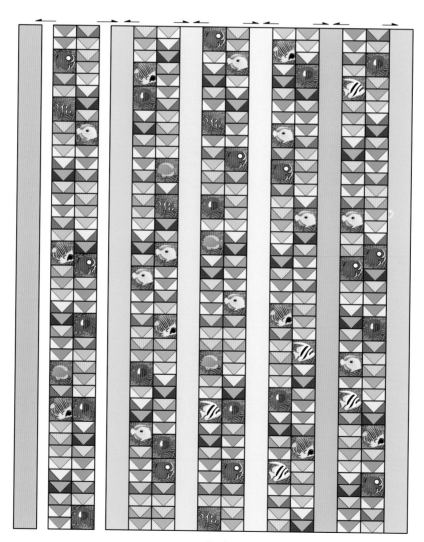

Quilt Plan

Another Look

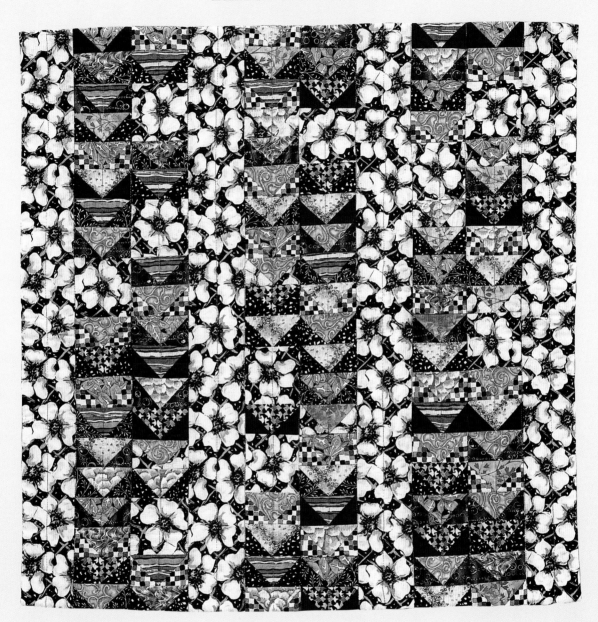

MIDNIGHT GARDEN

I made this smaller variation of "Undersea Garden" by replacing the colorful novelty prints with high-contrast black, white, and rose-colored flower fabrics for a blended floral look.

I fussy cut the Flower blocks from the same fabric as the sashing rows, and used that fabric in the Blender blocks as well. If you wish, you can use the same basic garden map to enlarge this quilt from a small wall piece to a bed-sized quilt. The possibilities are endless!

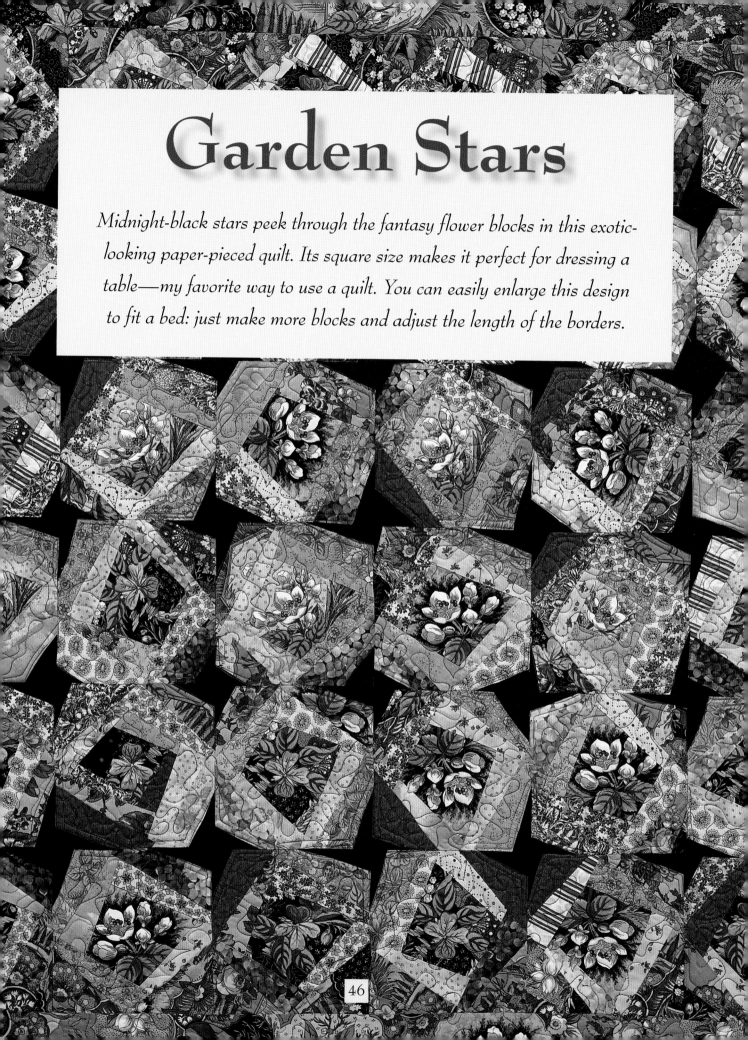

Garden Stars

Midnight-black stars peek through the fantasy flower blocks in this exotic-looking paper-pieced quilt. Its square size makes it perfect for dressing a table—my favorite way to use a quilt. You can easily enlarge this design to fit a bed: just make more blocks and adjust the length of the borders.

CHOOSING YOUR FABRICS

Take your 6½" acrylic square with you when shopping for the floral fabric for this quilt. When you find a fabric you love, place your ruler over the flower motif to make sure you like what you see. The flower itself doesn't need to fill the square; surrounding leaves and background can be included in the block center as well. Choose lots of go-with fabrics in coordinating colors and a variety of print sizes.

Materials

Yardage requirements are based on 42"-wide fabric.

- 3½ yards of large-scale floral print for fussy-cut block centers, blocks, inner and outer borders, and binding★
- 4¼ yards *total* of assorted purple, pink, gold, and green prints for blocks
- 1¼ yards of black solid or subtle print for block corners (stars)
- ½ yard of medium-scale floral print for middle border
- 3⅞ yards of fabric for backing
- 68" x 68" piece of batting
- 6½" acrylic square ruler

★*Amount will vary depending on the print.*

You're the Designer!

The cutting instructions reflect the precise number of floral print, assorted print, and black pieces needed to make a quilt just like the one pictured on page 48. However, this is such a wonderfully scrappy quilt that you might want to indulge yourself and cut extra pieces to play with. Don't be afraid to experiment!

You might also prefer to cut and sew as you go. Try cutting enough floral and assorted-print pieces to make about one quarter of the blocks at a time. As you complete each group, put them on your design wall and stand back to take a look. You might discover that you love some of the color and print combinations but don't like others. As you piece the next group of blocks, eliminate combinations that don't work as well and make more of those you love.

Cutting

These cutting instructions yield enough pieces to make the entire quilt. Cut all strips from the width of the fabric. Refer to "Fussy Cutting" on page 9 as needed.

From the large-scale floral print, fussy cut:
 36 flower squares, 6½" x 6½"

From the remaining large-scale floral print, cut:
 8 strips, 3" x 42"; crosscut into 44 pieces, 3" x 6"

 18 strips, 2½" x 42"

From the assorted purple, pink, gold, and green prints, cut a *total* of:
 288 pieces, 3" x 6"

From the black solid or subtle print, cut:
 13 strips, 3" x 42"; crosscut into 100 pieces, 3" x 5"

From the medium-scale floral print, cut:
 6 binding strips, 2½" x 42"

Designing the Quilt

• Use the floral-print fabrics around the outside of the paper-pieced blocks to help the blocks blend into the floral-print border.

• Add variety and movement by turning the Background blocks so the flowers in the block centers face in different directions.

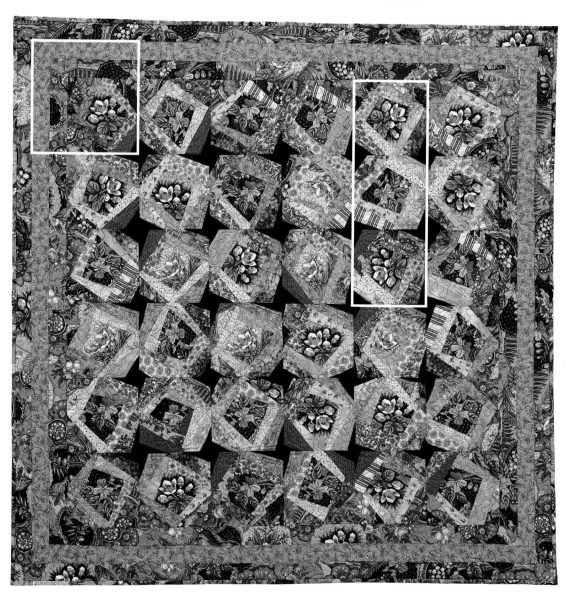

Finished quilt size: 60½" x 60½" • **Finished block size:** 8"

Making the Blocks

The Blender blocks and Background blocks are constructed the same way: the only difference is in the fabrics you'll use. When paper piecing, you'll want to set your machine-stitch length a bit shorter than usual. Add the pieces in numerical sequence, and square up each completed block to 8½".

Blender Blocks

For the perimeter blocks, you need a total of 20 paper-pieced Blender blocks in two variations: 16 of Blender block A and 4 of Blender block B.

Blender Block A

1. Enlarge the paper-piecing pattern on page 53 as instructed and make 16 copies.

2. For each block, begin by pinning a fussy-cut flower square (piece 1) right side up in position on the unmarked side of the paper pattern. Make sure you have positioned the fabric piece so that it completely covers section 1 on the paper pattern. Hold the pattern up to a light source and adjust as necessary.

3. With right sides together, position the edge of an assorted purple, pink, gold, or green piece (piece 2) so that it overlaps the line between pieces 1 and 2. Turn the pattern over so the markings are visible and stitch on the line between pieces 1 and 2. Begin and end with a few stitches before and after the line.

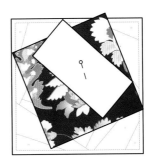

4. Turn the pattern over and trim the fabric seam allowance to ¼". Flip piece 2 open so the right side is face up, and press with a dry iron.

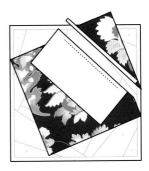

Trim seam allowance to ¼".

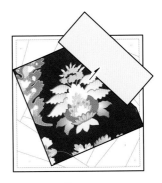

Press.

5. Repeat steps 3 and 4 to add pieces 3, 4, and 5, using the 3" x 6" assorted print pieces.

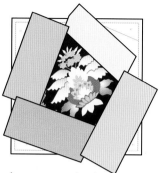

6. Repeat the paper-piecing process to add pieces 6, 7, 8, and 9, using 3" x 6" assorted print pieces; pieces 10 and 11, using 3" x 6" large-scale floral-print pieces; and pieces 12 and 13, using 3" x 5" black pieces.

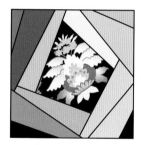

Blender Block A
Make 16.

7. Repeat steps 2–6 to make 16 blocks.

Blender Block B

Enlarge and make four copies of the paper-piecing pattern on page 53. Repeat steps 2–6 of "Blender Block A" (page 49), using assorted print pieces for sections 2–9. Use large-scale floral-print pieces for sections 10, 11, and 13, and a black piece for section 12. Make four blocks.

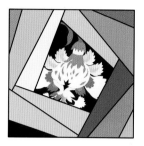

Blender Block B
Make 4.

Background Blocks

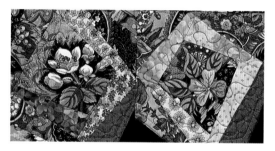

You need 16 Background blocks for the center of this quilt. Repeat steps 1–6 of "Blender Block A" (page 49) using 3" x 6" assorted print pieces for sections 2–9 and 3" x 5" black pieces for sections 10–13. Make 16 blocks.

Background Block
Make 16.

Putting It Together

Refer to the photo on page 48 and the garden map below for guidance in placing the Blender blocks and Background blocks. You may wish to experiment with moving the blocks around until you find the perfect arrangement, just as you would move flowers in your real-life garden.

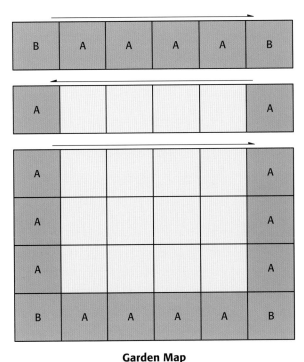

Garden Map

■ Blender blocks

□ Background blocks

1. Sew the blocks into six horizontal rows of six blocks each as shown. Press the seams in opposite directions from row to row. Sew the rows together; press. Carefully remove the paper foundations.

2. Referring to "Adding Borders" on page 89, sew 11 of the 2½"-wide large-scale floral strips end to end to make one long border strip. Trim and sew borders to the sides, top, and bottom of the quilt. Press the seams toward the border. Set the remaining length of border strip aside.

3. Piece, trim, and sew the 2½"-wide medium-scale floral strips to the sides, top, and bottom of the quilt. Press the seams toward the newly added border.

4. Trim the remaining length of the 2½"-wide large-scale floral strip and sew borders to the sides, top, and bottom of the quilt. Press the seams toward the newly added border.

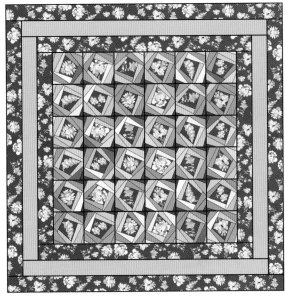

Quilt Plan

Finishing Your Quilt

Refer to "General Instructions," beginning on page 89, for specific instructions for each of the following finishing steps.

1. Layer the quilt top with batting and backing; baste.

2. Quilt heavily in a favorite allover pattern.

3. Use the remaining seven 2½"-wide large-scale floral strips to bind the quilt edges.

Another Look

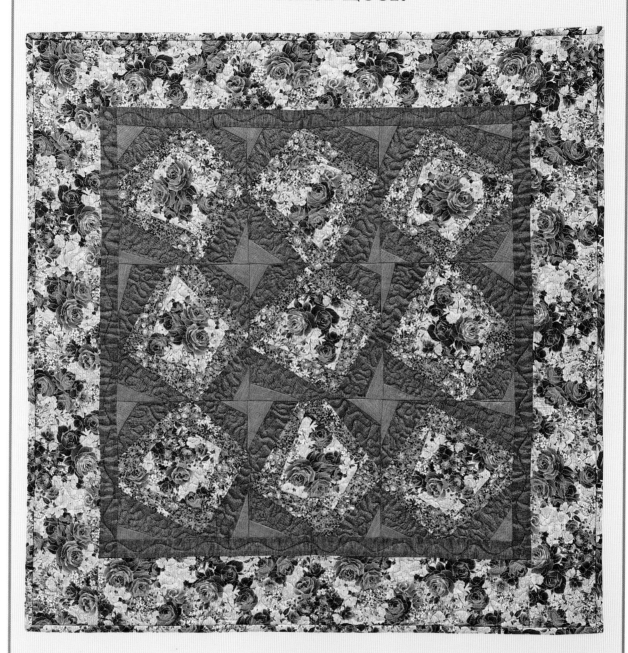

GARDEN GLITZ

Cotton lamé gives this nine-block "Garden Stars" variation a touch of garden glitz. This smaller version—with its limited palette of fabrics—offers an elegant and sophisticated alternative to the scrappy and vibrant original.

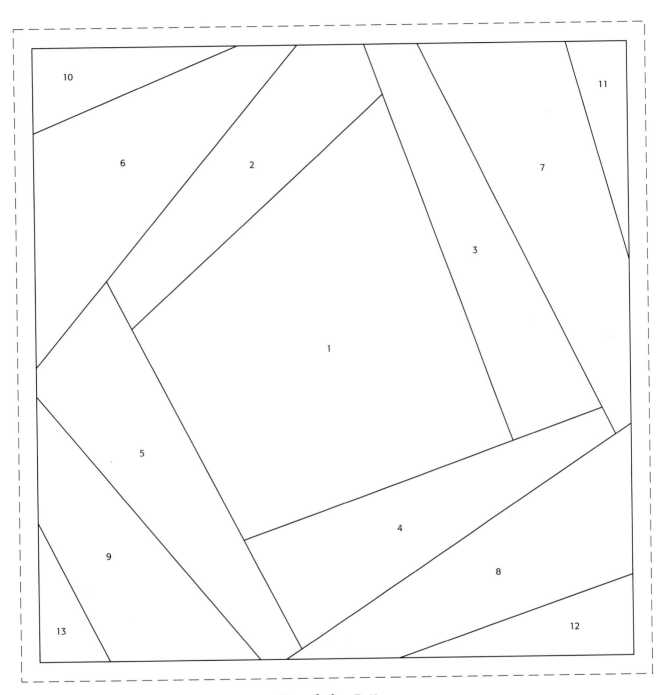

Foundation Pattern

Enlarge pattern 125%.

Patti's Quilt

Black and red are my friend Patti's favorite colors,
so of course she thought this quilt should be hers! I told her
I just couldn't do that, but I could name the quilt for her instead.
There's no doubt about it—this one is definitely a garden showstopper!

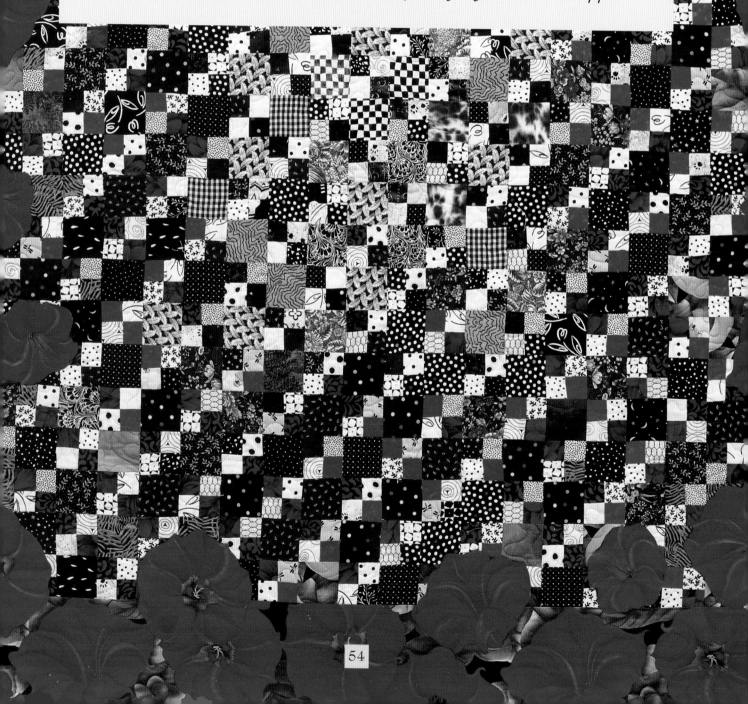

CHOOSING YOUR FABRICS

Look for a floral fabric with the largest possible flowers. The flowers in the print I selected measure about 6" across and have smooth, rounded edges, making them easier to appliqué. If you choose a print with smaller flowers, you may want to reduce the number of blocks in your quilt. This will keep the pieced center in proportion to the border. As for the companion fabrics, the more different prints of each color you use, the more exciting your quilt will be!

Materials

Yardage requirements are based on 42"-wide fabric.

- 1½ yards of large-scale floral print for *broderie perse* appliqué and border★
- 1 yard *total* of assorted black prints for blocks
- ¾ yard *total* of assorted white-and-black prints for blocks
- ⅔ yard *total* of assorted red prints for blocks
- ⅓ yard *total* of assorted green prints for blocks
- ¼ yard *total* of assorted medium and dark gray prints for blocks
- 3⅜ yards of fabric for backing
- ⅜ yard of black print for binding
- 60" x 60" piece of batting

★*Amount will vary depending on the print.*

You're the Designer!

Though somewhat controlled in the placement of colors and values, this is basically a scrappy quilt. You'll notice that I occasionally placed a red-and-white four-patch unit where a black-and-white one "should" be, and that I sometimes substituted a large green square for a black one. That's all part of the fun! The cutting and piecing instructions take these quirky variations into account.

You might find it fun to mix it up even more and cut a few additional strips and squares of each color. That way, you can make even more substitutions within the blocks for variety.

The Background blocks are lighter in value than the Blender blocks and therefore create a light area in the center of the quilt. If you prefer to make the light area of your quilt larger, make more Background blocks and fewer Blender blocks than indicated in the project instructions and on the garden map on page 59.

Cutting

Cut all strips across the width of the fabric.

From the assorted white-and-black prints, cut a *total* of:
30 strips, 1½" x 21"

From the assorted red prints, cut a *total* of:
23 strips, 1½" x 21"

From the assorted green prints, cut:
2 strips, 1½" x 21"

20 squares, 2½" x 2½"

From the assorted black prints, cut a *total* of:
5 strips, 1½" x 21"

148 squares, 2½" x 2½"

Designing the Quilt

• For an unexpected touch, incorporate a red square or two into the black and white four-patch units of the Background blocks.

• Position the Blender blocks so that the green squares are nearest the border, making a smooth transition from the pieced quilt center to the border print.

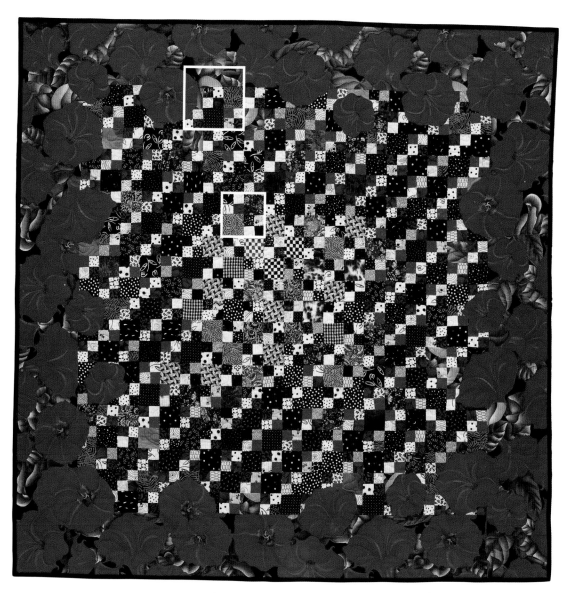

Finished quilt size: 52½" x 52½" • **Finished block size:** 4"

From the assorted medium and dark gray prints, cut a *total* of:
32 squares, 2½" x 2½"

From the large-scale floral print, cut:
5 strips, 6½" x 42"

From the black print for binding, cut:
6 binding strips, 2½" x 42"

Making the Blocks

 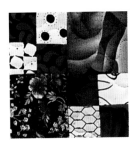

You'll use a combination of Blender blocks and Background blocks to make this quilt. The blocks are constructed in the same way; the only difference is in the fabrics you'll use to make them. You'll make and crosscut the strip sets first. This allows you the most variation when you assemble the four-patch units and put the blocks together, resulting in a wonderfully scrappy look. Square up each completed block to 4½".

Making Strip Sets

1. With right sides together, sew a white-and-black strip and a red strip together to make a strip set as shown; press. Make 23 strip sets and cut them into 320 segments, 1½" wide. You will use these segments primarily in the Blender blocks.

1½"

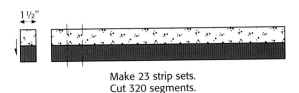

Make 23 strip sets.
Cut 320 segments.

2. Repeat step 1 using white-and-black strips and the green strips. Make two strip sets and cut them into 16 segments, 1½" wide. You will use these segments in the Blender blocks.

1½"

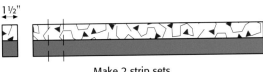

Make 2 strip sets.
Cut 16 segments.

3. Repeat step 1 using the remaining white-and-black strips and the strips of black print. Make five strip sets and cut them into 64 segments, 1½" wide. You will use these segments primarily in the Background blocks.

1½"

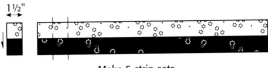

Make 5 strip sets.
Cut 64 segments.

Blender Blocks

You need 84 Blender blocks for this quilt.

1. Using the segments you created in "Making Strip Sets," sew two different black-and-white and red segments together as shown; press. For variation, substitute an occasional segment that uses green or black in place of red. Make 168 four-patch units.

Make 168.

Another Look

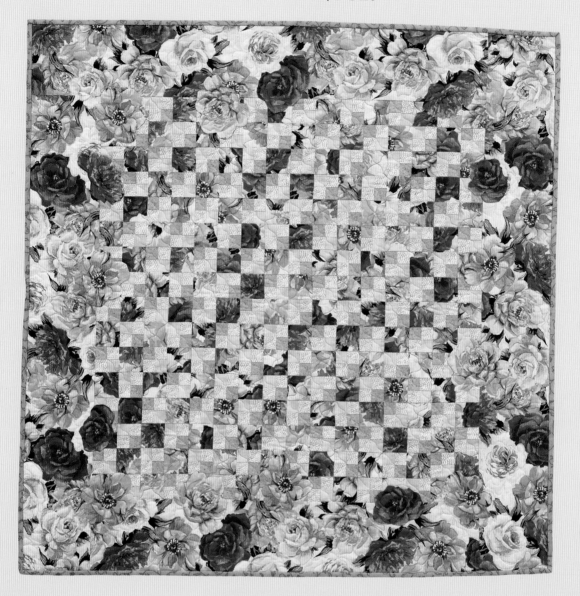

PRETTY AND PINK

Soft garden shades of pink, with touches of yellow, take on a classic cottage-garden look in this variation of "Patti's Quilt." The quilt assumes a totally different personality, not only because of the change in the color intensity, but also because the larger squares in the pieced blocks dominate the smaller ones. I cut the larger squares from the border fabric, which helped to blend the pieced center with the border.

Because the flowers in this print are smaller, I reduced the number of blocks in the pieced center so that it wouldn't look too large in comparison to the flowers.

2. Arrange and sew together two of the four-patch units and two different black print squares as shown; press. For variation, substitute an occasional green square for one of the black squares. Make 84 blocks.

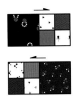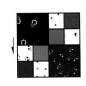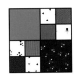

Make 84.

FAST FORWARD

Try chain-piecing to assemble these simple blocks more quickly. Sew two units from step 1 together to make a four-patch unit, and then feed another two of the same unit under the presser foot without cutting the thread in between. Continue in this manner until you have the required number of four patches for your quilt. Then stop sewing, cut the units apart, and press. Piece these units into larger units, using the 2½" squares from step 2 and following the same technique. Finish by sewing the new, larger units together to complete the block.

Background Blocks

You need 16 Background blocks for this quilt.

1. Using the segments you created in "Making Strip Sets," sew two different white-and-black and black print segments together as shown; press. For variation, substitute an occasional segment that uses red in place of black. Make 32 four-patch units.

Make 32.

2. Arrange and sew together two of the four-patch units and two different medium or dark gray squares as shown; press. Make 16 blocks.

Make 16.

Putting It Together

Refer to the photo on page 56 and the garden map below for guidance in placing the Blender blocks and Background blocks. You may wish to experiment with moving the blocks around until you find the perfect arrangement, just as you would move flowers in your real-life garden.

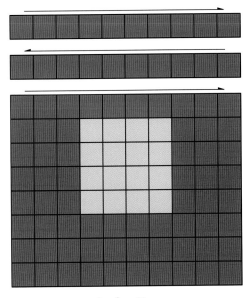

Garden Map

Blender blocks

Background blocks

1. Sew the blocks into 10 horizontal rows of 10 blocks each as shown. Press the seams in opposite directions from row to row. Sew the rows together; press.

2. Refer to "Adding Borders" on page 89 to piece, trim, and sew the 6½"-wide floral strips to the quilt, matching the print as much as possible as you piece the strips together. Press the seams toward the border.

3. Refer to the photo, the garden map, and "*Broderie Perse* Appliqué" on page 10. From the remaining floral fabric, cut out flowers to match the images interrupted by the seam between the body of the quilt and the borders. Don't forget to add a ¼" turn-under allowance around each appliqué shape.

4. Appliqué the flowers over the seam between the body of the quilt and the border strips to blend the two areas. Using the photo as a guide, add several additional flowers around the outer edges of the pieced quilt center.

Finishing Your Quilt

Refer to "General Instructions," beginning on page 89, for specific instructions for each of the following finishing steps.

1. Layer the quilt top with batting and backing; baste.

2. Quilt around the outside of the appliquéd flowers, about ⅛" from the edge. Quilt inside the flowers following the outline of the petals. Quilt the rest of the quilt in a favorite allover pattern.

3. Use the 2½"-wide black strips to bind the quilt edges.

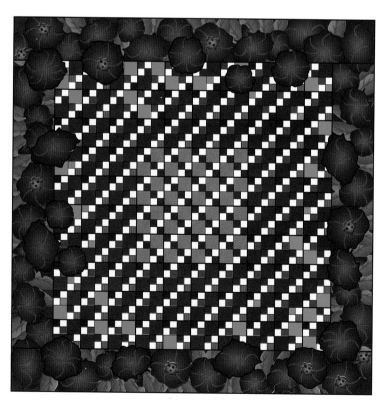

Quilt Plan

Bouquets for Brooklynn

Morning glories in shades of pink and white are scattered on this baby quilt I made for my granddaughter Brooklynn (and for her mother). I fussy cut the flowers for the center of the Blender blocks. Then I placed the darker blooms on the outside edges of the quilt and the lighter ones toward the center.

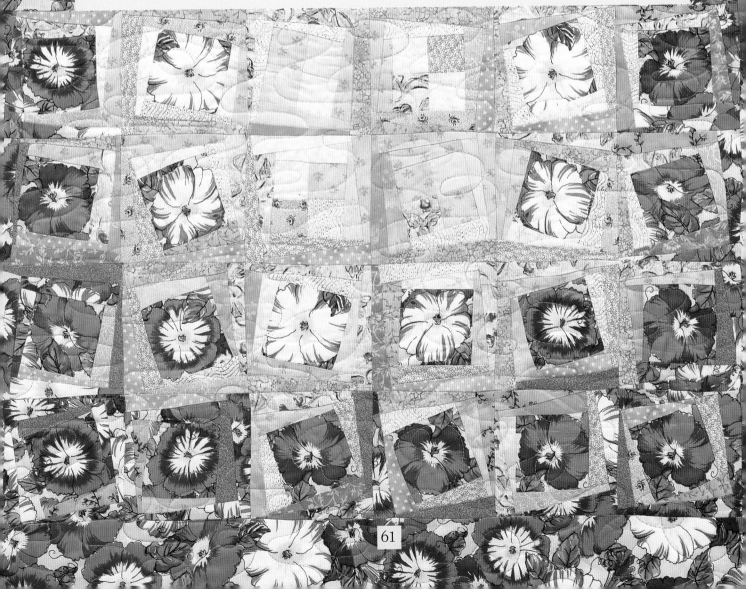

CHOOSING YOUR FABRICS

To blend the colors from light in the center to dark at the outside, shop for a floral print with flowers that measure about 3" square and appear in the fabric in several shades. If you wish, you can select two or more different fabrics with varying colors or color intensities and still create the blended look. Be sure to choose a fabric for fussy cutting that includes some flowers that don't overlap.

Materials

Yardage requirements are based on 42"-wide fabric.

- 2 yards of large-scale floral print for blocks and inner border★
- 1½ yards *total* of assorted medium pink and medium green prints for blocks
- 1⅛ yards *total* of assorted light pink and light green prints for blocks
- ⅔ yard of dark pink print for outer border and binding
- ⅜ yard *total* of assorted yellow prints for blocks
- ¼ yard of medium pink print for middle border
- 3 yards of fabric for backing
- 50" x 65" piece of batting
- 3½", 4½", and 5½" acrylic square rulers

★*Amount will vary depending on the print.*

You're the Designer!

The "catawampus" Log Cabin–style blocks in this quilt are scrappy, and I give you a number of fabric and color options to choose from as you sew. I've also given you a bit of wiggle room in the number of 1½" x 7" pieces listed in the cutting instructions, and you will cut a few more pieces than you will ultimately use. Not to worry. Set those aside for another project.

If you like, you can cut and sew the blocks as you go. Cut enough pieces to complete about one quarter of the blocks at a time. Put the blocks up on your design wall, and then stand back to assess how the fabric and color combinations are blending. As you move on to the next group of blocks, you can eliminate combinations that are less effective, and make more of the ones you love.

Cutting

These cutting instructions yield enough pieces to make the entire quilt. Cut all strips across the width of the fabric. Refer to "Fussy Cutting" on page 9 as needed.

From the large-scale floral print, fussy cut:
22 dark flower squares, 3½" x 3½"

14 light flower squares, 3½" x 3½"

From the remaining large-scale floral print, cut:
18 strips, 1½" x 42"; crosscut into 90 pieces, 1½" x 7"

4 strips, 4½" x 42"

From the assorted medium pink and medium green prints, cut a *total* of:
160 pieces, 1½" x 7"

From the assorted light pink and light green prints, cut a *total* of:
120 pieces, 1½" x 7"

Designing the Quilt

• Turn the blocks so that the lighter sides are facing the center of the quilt.

• Choose light flower squares for the centermost blocks and darker flower squares for blocks around the edges of the quilt.

• Floral framing strips blend the outer blocks with the floral border.

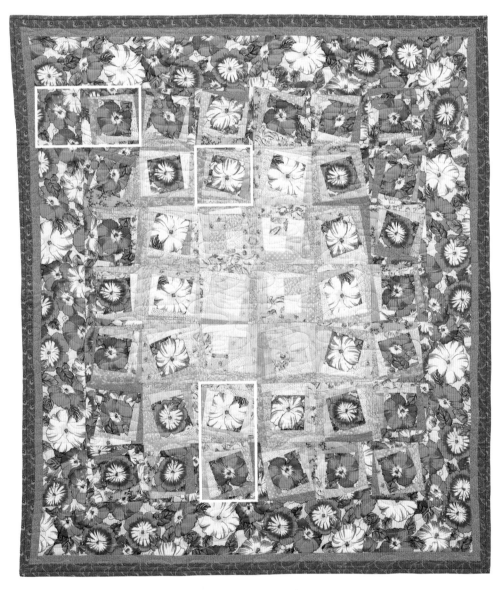

Finished quilt size: 38½" x 43½" • **Finished block size:** 5"

From the assorted yellow prints, cut a
total **of:**

 20 pieces, 1½" x 7"

**From the remaining assorted light pink,
light green, and yellow prints, cut a**
total **of:**

 24 squares, 2" x 2"

From the medium pink border fabric, cut:

 4 strips, 1½" x 42"

From the dark pink fabric, cut:

 5 strips, 1½" x 42"

 5 binding strips, 2½" x 42"

Making the Blocks

 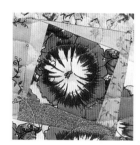

You'll need Background blocks and two varia-
tions of Blender blocks (dark and medium) for
this quilt. Both types of Blender blocks feature
fussy-cut flower centers and are constructed in
exactly the same way; the only difference is in
the fabrics you'll use to make them. The Back-
ground blocks use a scrappy four-patch unit in
the center. Feel free to vary the numbers of the
various blocks; just be sure the overall look of
the quilt blends smoothly.

Dark Blender Blocks

You need 22 dark Blender blocks for this quilt.
The blocks are scrappy, so mix the various me-
dium pink and medium green prints freely.

1. Sew a 1½" x 7" medium pink or medium
 green piece to one side of a 3½" dark

flower square. Trim the piece even with the
edge of the square as shown; press.

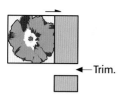

2. Sew a different 1½" x 7" medium pink or
 medium green piece to an adjacent side
 of the unit from step 1 as shown; trim and
 press.

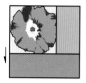

3. Sew a 1½" x 7" medium pink or floral
 print piece to both remaining sides of the
 unit as shown; trim and press. The unit
 should measure 5½" x 5½".

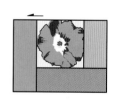 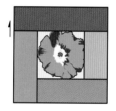

4. Position a 4½" acrylic square ruler at an
 angle on top of the unit from step 3. Hold
 the ruler firmly in place and use a rotary
 cutter to trim all sides of the unit as shown.

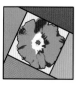

5. Repeat steps 1–3 to add medium pink or medium green pieces to two sides of the unit and floral print pieces to the two remaining sides. Position a 5½" acrylic square ruler at an angle on top of the unit and trim.

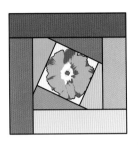

6. Repeat steps 1–5 to make 22 blocks.

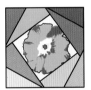

Dark Blender Block
Make 22.

Medium Blender Blocks

You will need 14 medium Blender blocks for this quilt. The blocks are scrappy, so mix the various shades of pink and green prints freely.

1. Repeat steps 1–4 of "Dark Blender Blocks" (page 64) to sew a 1½" x 7" light pink or light green piece to each side of a 3½" light flower square. Use a 4½" acrylic square ruler to trim the unit.

2. Repeat step 5 of "Dark Blender Blocks" to add light pink or light green pieces to two sides of the unit and medium pink or medium green pieces to the two remaining sides. Use a 5½" acrylic square ruler to trim the block.

3. Repeat steps 1 and 2 to make 14 blocks.

Medium Blender Block
Make 14.

Background Blocks

You need six Background blocks for this quilt. The blocks are scrappy, so mix the various light pink, light green, and yellow prints freely.

1. Sew the assorted light pink, light green, and yellow squares together in random pairs; press. Make 12. Sew random pairs together to make a four-patch as shown; press. Make six.

Make 6.

2. Repeat the procedure for making the Blender blocks, using a four-patch unit from the previous step as the block center and assorted 1½" x 7" light pink, light green, and yellow pieces for the two "rounds." Make six blocks.

Background Block
Make 6.

Putting It Together

Refer to the photo on page 63 and the garden map below for guidance in placing the dark Blender blocks, medium Blender blocks, and Background blocks. You may wish to experiment with moving the blocks around until you find the perfect arrangement, just as you would move flowers in your real-life garden.

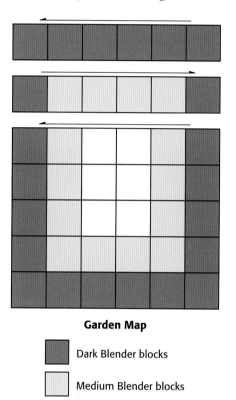

Garden Map

■ Dark Blender blocks

▨ Medium Blender blocks

□ Background blocks

1. Sew the blocks into seven horizontal rows of six blocks each as shown. Press the seams in opposite directions from row to row. Sew the rows together; press.

2. Refer to "Adding Borders" on page 89 to piece, trim, and sew the 4½"-wide floral strips to the sides, top, and bottom of the quilt. Press the seams toward the border.

Repeat to add the 1½"-wide medium pink strips for the middle border, and then the 1½"-wide dark pink strips for the outer border. Press the seams toward each newly added border.

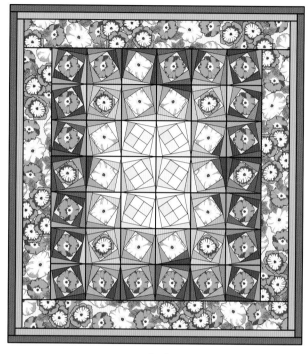

Quilt Plan

Finishing Your Quilt

Refer to "General Instructions," beginning on page 89, for specific instructions for each of the following finishing steps.

1. Layer the quilt top with batting and backing; baste.

2. Quilt heavily in a favorite allover pattern.

3. Use the 2½"-wide dark pink strips to bind the quilt edges.

Another Look

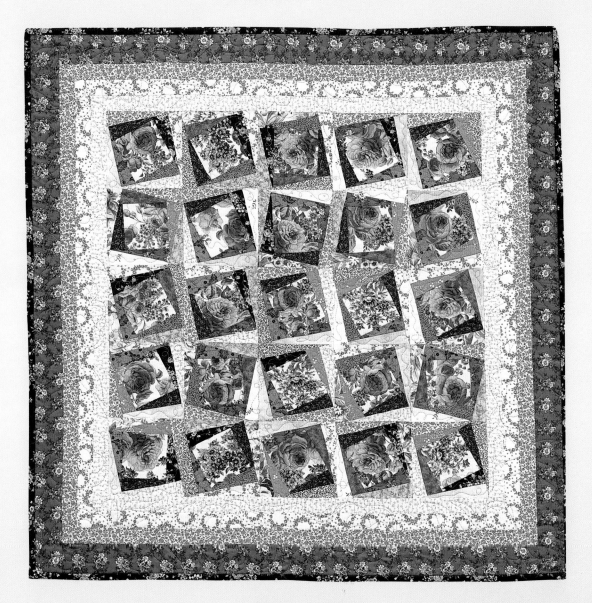

A FIELD OF BLUE

Classic blue-and-white prints lend a traditional air to this smaller variation of "Bouquets for Brooklynn." By eliminating the center background, you'll find that five rows of five scrappy blocks each make a quilt perfectly sized for the center of the table in your kitchen or dining room. I used darker prints in the first round of pieces and lighter prints for the second round to emphasize the fussy-cut flowers in the block center.

The print I fussy cut for the repeating blocks included a variety of roses and other flowers. If you wish, you can use more than one print for variety in your fussy-cut blooms.

Wildflowers

This is a definite garden-show winner! Vibrant hot-pink Flower blocks scatter in blended horizontal rows across this spectacular quilt. The garden map suggests an arrangement for these scattered flowers, but you can easily create a different look by turning and rearranging them, adding more, or experimenting with more than one fussy-cut motif.

CHOOSING YOUR FABRICS

Select a floral print with flowers that measure about 3½" square, or use several different prints in similar colors for variety. Since this quilt includes so many Flower blocks, you'll use a large amount of fabric for the fussy-cut flowers; it's a good idea to purchase more than you think you'll need. To achieve the high-contrast look you see in "Wildflowers," select medium and dark shades of pink and orange fabrics that pick up the colors in the floral print. Then choose very light pink and pink-and-white prints for the lighter blocks.

Materials

Yardage requirements are based on 42"-wide fabric.

- 3 yards of large-scale floral print for fussy-cut flowers and blocks★
- 2½ yards *total* of assorted light pink and pink-and-white prints for blocks
- 1½ yards *total* of assorted medium pink, dark pink, and orange prints for blocks
- ⅞ yard of medium pink print for border and binding
- 3⅝ yards of fabric for backing
- 64" x 76" piece of batting
- 3½" acrylic square ruler

★*Amount will vary depending on the print.*

You're the Designer!

In the instructions, I've given you the number of Flower blocks and various Blender blocks that I used to make this quilt, but remember: you can add more of one type or less of another if you prefer. That's the fun of being the designer!

Instead of cutting all the strips for the Blender blocks at once, you might prefer to cut and sew as you go. The cutting instructions allow for a few more strips than you'll need to give you flexibility in making the strip sets. Try cutting enough strips to make about one quarter of the dark Blender blocks. When you've completed this first group of blocks, arrange them with the fussy-cut Flower blocks on your design wall. Refer to the garden map on page 72 and to the photo on page 70 for placement. Next, make about one quarter of the light Blender blocks and place those on the wall as well. Continue making groups of blocks until you can lay out an entire section of the quilt. Move the blocks around until you're pleased with the arrangement and feel you've made the quilt uniquely your own.

If you want your quilt to be the same size as mine, you'll need a total of 396 blocks arranged in 22 rows of 18 blocks each. If you'd rather make your quilt a different size, simply increase or reduce the number of blocks and/or rows until the quilt is just the size you want.

Designing the Quilt

• Place a lighter strip at the end of each dark Blender block to help blend the lights and darks. Place a darker strip at the end of each light Blender block for the same blending effect.

• To create a soft look in the lighter areas of the quilt, try placing the Flower blocks wrong side up.

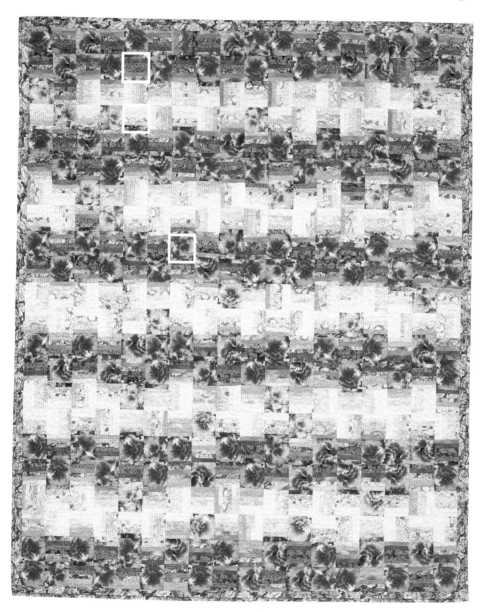

Finished quilt size: 56½" x 68½" • **Finished block size:** 3"

Cutting

These cutting instructions yield enough pieces to make the entire quilt. Cut all strips across the width of the fabric. Refer to "Fussy Cutting" on page 9 as needed.

From the large-scale floral print, fussy cut:

136 flower squares, 3½" x 3½"

From the remaining large-scale floral print, cut:

10 strips, 1" x 21"

From the assorted medium pink, dark pink, and orange prints, cut a *total* of:

105 strips, 1" x 21"

From the assorted light pink and pink-and-white prints, cut a *total* of:

170 strips, 1" x 21"

From the medium pink border and binding fabric, cut:

7 strips, 1½" x 42"

7 binding strips, 2½" x 42"

Dark Blender Blocks

You need 101 dark Blender blocks for this quilt. With right sides together, sew assorted medium pink, dark pink, and orange strips together along their long edges to make a strip set as shown; press. Make 17 strip sets and cut them into 101 segments, 3½" wide.

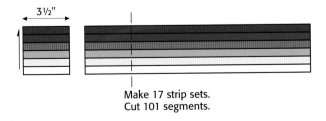

Make 17 strip sets.
Cut 101 segments.

BLENDING TIP

When making strip sets for the dark Blender blocks, I sometimes substituted a large floral print for the first strip in the set. For the rest, I began with one of the darker strips from my cut assortment. I finished the strip set with a light pink or pink-and-white print so that the dark Blender blocks cut from the strip set would blend nicely into the lighter areas.

I did the reverse with the light strip sets for the light Blender blocks, beginning with one of my lightest strips and ending some of the sets with a medium strip. Light Blender blocks cut from the strip set blended into the darker areas.

Light Blender Blocks

You need 159 light Blender blocks for this quilt. Repeat the procedure described in "Dark Blender Blocks," using the light pink and pink-and-white strips to make the strip sets. Make 27 strip sets, and then cut them into 159 segments, 3½" wide.

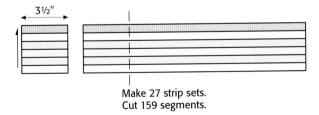

Make 27 strip sets.
Cut 159 segments.

Putting It Together

Refer to the photo on page 70 and the garden map below for guidance in placing the Flower blocks and various Blender blocks. You may wish to experiment with moving the Blender blocks around until you find the perfect arrangement, just as you would move flowers in your real-life garden.

Garden Map

■ Flower blocks

▨ Dark Blender blocks

□ Light Blender blocks

1. Sew the blocks into 22 horizontal rows of 18 blocks each as shown. Press the seams in opposite directions from row to row. Sew the rows together; press.

2. Refer to "Adding Borders" on page 89 to piece, trim, and sew the 1½"-wide medium pink strips to the sides, top, and bottom of the quilt. Press the seams toward the border.

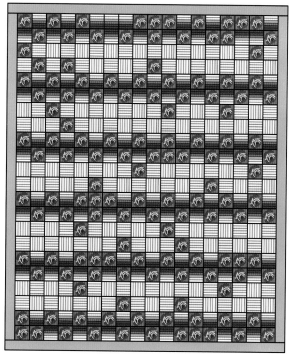

Quilt Plan

Finishing Your Quilt

Refer to "General Instructions," beginning on page 89, for specific instructions for each of the following finishing steps.

1. Layer the quilt top with batting and backing; baste.

2. Quilt heavily in a favorite allover pattern.

3. Use the 2½"-wide medium pink strips to bind the quilt edges.

Another Look

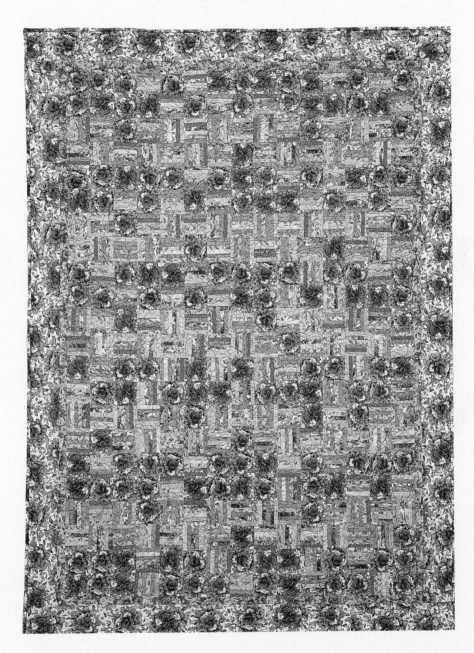

PURPLE VIOLETS

Bouquets of violets dance across this alternative version of "Wildflowers," giving it all the charm of a garden wedding. The Blender blocks are pieced in a scrappy style, with less contrast between the coordinating fabrics and the Flower blocks than in the original quilt. And the flowers are everywhere, just like blooming violets in the spring!

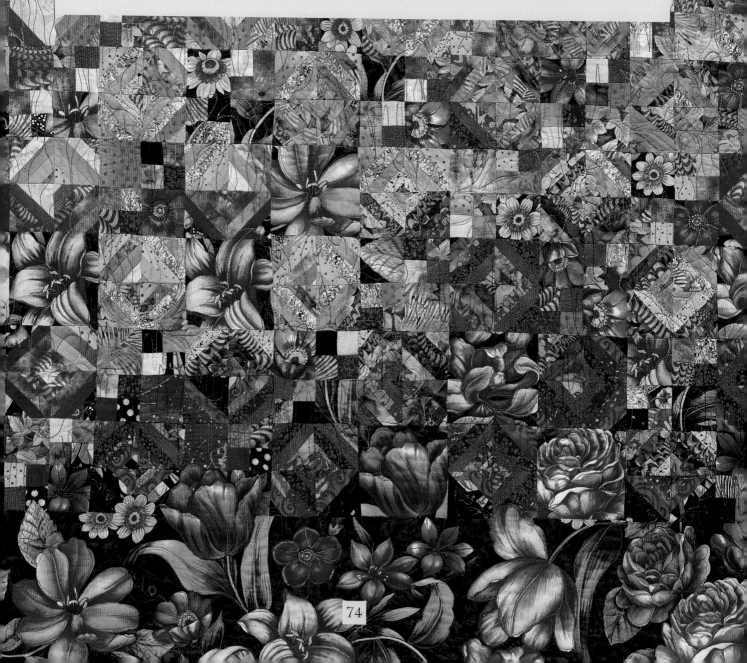

Tropical Tulips

Here is your chance to have fun and really "mix it up" in an exciting Scatter Garden quilt. I've alternated just a few fussy-cut Flower blocks with two varieties of pieced Blender blocks, with "zillions" of prints, tints, and shades, and bits of overlapping colors to create the blend. For the final blending touch, I added large broderie perse appliquéd flowers at the bottom of the quilt.

CHOOSING YOUR FABRICS

Look for an absolutely *dynamite* floral fabric as a start for this quilt—one with lots of colors and with flowers that measure about 4" square. My focal fabric was a wild, jungle-like print with lots of movement. In addition to the large flowers, the fabric also featured smaller blooms that measured about 2" square. I fussy cut these and worked them into the pieced blocks. (You can substitute flowers from a second fabric if you prefer.) I selected coordinating fabrics in four color groups for the two types of Blender blocks. To help the overall blend, I made sure that some of the prints contained bits of colors from other groups.

Materials

Yardage requirements are based on 42"-wide fabric.

- 1 yard of focal floral print for fussy-cut flowers★
- 1⅛ yards *total* of many assorted orange prints for blocks
- ¾ yard *total* of many assorted yellow prints for blocks
- ¾ yard *total* of many assorted green prints for blocks
- ⅝ yard *total* of many assorted blue and purple prints for blocks
- 1⅓ yards of fabric for backing
- ¾ yard of fabric for facing
- 48" x 56" piece of batting
- 2½" and 4½" acrylic square rulers

★*Amount will vary depending on the print.*

You're the Designer!

I've given you the number of Blender blocks I made in each colorway, and the cutting instructions reflect those numbers. However, you might prefer a different look for your quilt, or the fabrics you select might "suggest" that you make more (or fewer) blocks in one color or another. Why not cut a few additional pieces in each color now so that you have a few extras on hand for replacements or substitutions later?

As another option, this quilt is a great candidate for the cut-and-sew-as-you-go method. Try cutting enough pieces to make about one quarter of the blocks at a time, in the same basic colorway, and then arrange them on your design wall. This will help you determine which fabrics (and which colors) to cut and piece next, and help you decide where you might want to mix the colors a bit to create a smooth transition between blocks. Continue cutting, sewing, and arranging groups of blocks until you have the number you need for your quilt. Move the blocks around until you get just the look you want. With this quilt, anything goes!

Cutting

These cutting instructions yield enough pieces to make the entire quilt. Cut all strips across the width of the fabric. Refer to "Fussy Cutting" on page 9 as needed.

From the focal floral print, fussy cut:
8 flower squares, 4½" x 4½"

15 flower squares, 2½" x 2½"

From the remaining focal floral print, cut:
1 strip, 8½" x 40½"

Designing the Quilt

- Introduce a bit of color from neighboring blocks to help Blender blocks transition smoothly from color to color.

- Replace some of the colored-print squares in Blender Block 1 with flower squares for variety.

- To create a blended look, appliqué flowers and leaves at the seam between the body of the quilt and the border.

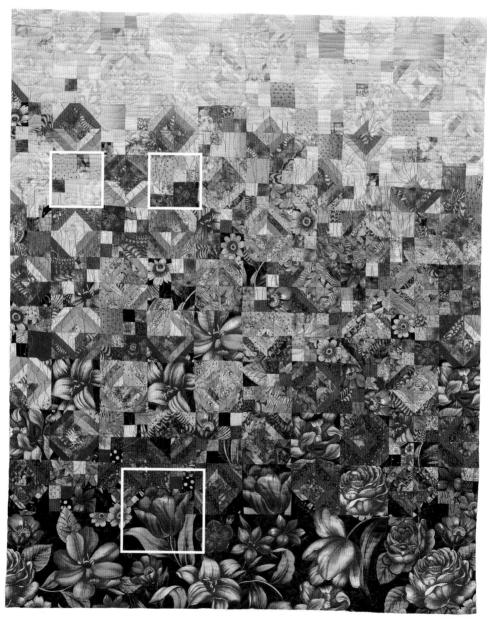

Finished quilt size: 40½" x 48½" • **Finished block size:** 4"

From the assorted yellow prints, cut a *total* of:

24 squares, 2½" x 2½"

96 squares, 1½" x 1½"

24 strips, 1" x 21"

From the assorted orange prints, cut a *total* of:

30 squares, 2½" x 2½"

120 squares, 1½" x 1½"

48 strips, 1" x 21"

From the assorted green prints, cut a *total* of:

20 squares, 2½" x 2½"

80 squares, 1½" x 1½"

24 strips, 1" x 21"

From the assorted blue and purple prints, cut a *total* of:

10 squares, 2½" x 2½"

40 squares, 1½" x 1½"

24 strips, 1" x 21"

From the facing fabric, cut:

5 strips, 4½" x 42"

Making the Blocks

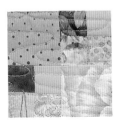 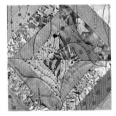

For this quilt you need two different Blender blocks—Block 1 and Block 2—in four different colorways. Make a total of 92 Blender blocks. I made the blocks as follows:

- 24 yellow blocks (12 of Block 1 and 12 of Block 2)

- 32 orange blocks (15 of Block 1 and 17 of Block 2)

- 22 green blocks (11 of Block 1 and 11 of Block 2)

- 14 blue-and-purple blocks (5 of Block 1 and 9 of Block 2)

Square up each completed block to 4½".

Blender Block 1

For variation, substitute a 2½" flower square for a 2½" yellow, orange, green, or blue-and-purple square in some of the blocks.

1. Sew two different 1½" yellow squares together as shown; press. Make four. Sew two pairs together to make a four-patch unit as shown; press. Make two.

2. Arrange and sew the two four-patch units from step 1 and two different 2½" yellow squares as shown; press.

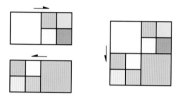

3. Repeat steps 1 and 2 to make 12 yellow blocks.

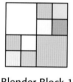

Blender Block 1
Make 12.

4. Repeat steps 1 and 2 using the 1½" and 2½" orange, green, and blue and purple squares to make 15 orange blocks, 10 green blocks, and 5 blue-and-purple blocks as shown.

Blender Block 1 Blender Block 1 Blender Block 1
Make 15. Make 10. Make 5.

Blender Block 2

1. With right sides together, sew 24 assorted 1" x 21" yellow strips together along their long edges to make a strip set as shown above right. Begin with the darkest or brightest strips and end with the lightest or softest shades to create a blended effect. Carefully press the strip set first from the back and then from the front.

2. Use the 45° mark on your clear acrylic ruler to find the bias of the strip-set panel, and cut as shown. Use this angled edge as a guide to cut a 2½"-wide pieced bias strip from the panel.

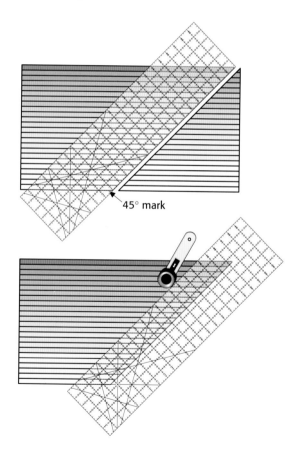

45° mark

3. Use a 2½" acrylic square ruler to cut 2½" squares from the bias strip as shown. Cut the strip set into 48 squares, 2½" each.

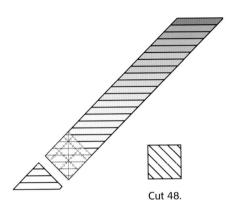

Cut 48.

4. Arrange four yellow squares from step 3 as shown. Experiment with the placement to preview the designs that are formed when you combine the squares. When you are pleased with the results, sew the squares together as shown; press. Make 12 yellow blocks.

Blender Block 2
Make 12.

5. Repeat steps 1–4 using the 1"-wide orange strips to make two strip sets. Cut 68 squares and make 17 orange blocks. Use the green strips to make one strip set. Cut 48 squares and make 12 green blocks. Use the blue-and-purple strips to make one strip set. Cut 36 squares and make 9 blue-and-purple blocks.

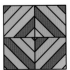

Blender Block 2
Make 17.

Blender Block 2
Make 12.

Blender Block 2
Make 9.

BLENDING TIP

You'll have enough strip-set leftovers to cut additional 2½" squares from each color-way. These extras will give you options as you make the blocks and allow you to make a replacement block or two if needed to improve a color blend as you assemble your quilt.

Putting It Together

Refer to the photo on page 76 and the garden map below for guidance in placing the Flower blocks and various Blender blocks. You may wish to move the blocks around until you find the perfect arrangement, just as you would move flowers in your real-life garden.

Garden Map

Yellow Blender blocks

Orange Blender blocks

Green Blender blocks

Blue-and-purple Blender blocks

Flower blocks

1. Beginning with a yellow Block 1 in the upper-left corner, arrange the blocks in 10 horizontal rows of 10 blocks each as shown.

BLENDING TIP

Once you've positioned the blocks on the design wall, give your quilt the "squint test." Stand back, squint your eyes, and make sure the colors blend smoothly.

If you see areas where the transition between colors is too abrupt or where a color seems too prominent, you may need to make a few replacement blocks to blend the overall design more smoothly. For example, perhaps you need another yellow block with a touch of green, or a blue block with a bit of orange to help neighboring blocks blend. You'll be glad you made the extra effort when you see the finished result, and you can save the discarded blocks for another project.

2. Sew the blocks into rows. Press the seams in opposite directions from row to row. Sew the rows together; press.

3. Sew the 8½" x 40½" floral strip to the bottom of the quilt. Depending on the print, you may want to trim this piece to a narrower width.

4. Refer to the photo, the garden map, and "*Broderie Perse* Appliqué" on page 10. From the remaining focal floral fabric, cut out flowers and/or leaves to match the ones interrupted by the seam between the body of the quilt and the bottom border. Don't forget to add a ¼" turn-under allowance around each appliqué shape

5. Appliqué the flowers and leaves over the seam between the body of the quilt and the border strip to blend the two areas. If you wish, cut extra flowers to appliqué to the pieced background.

Finishing Your Quilt

Refer to "General Instructions," beginning on page 89, for specific instructions for each of the following finishing steps.

1. Layer the quilt top with batting and backing; baste.

2. Quilt around the outside of the appliquéd and fussy-cut flowers. Quilt inside the flowers following the outline of the petals. Quilt the rest of the quilt heavily in a favorite allover pattern. If your quilt is very colorful and busy, you may want to use monofilament thread.

3. Use the 4½"-wide strips to add facings to the quilt edges.

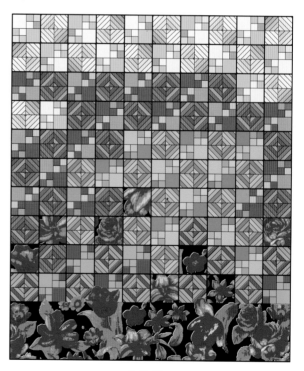

Quilt Plan

Another Look

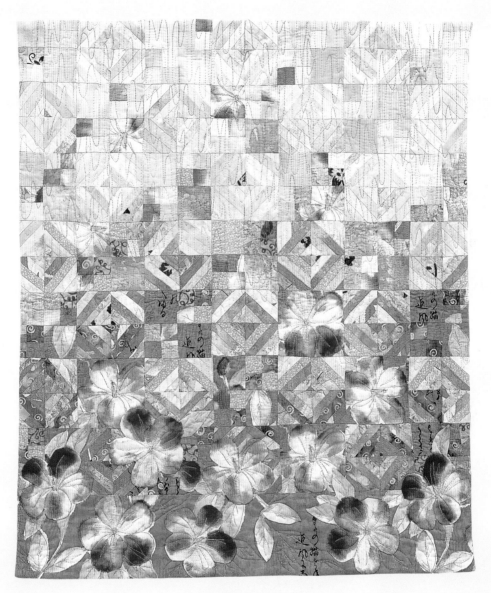

JASMINE

It's amazing how a garden can change, depending on the seeds you choose and how you scatter them! Instead of colorful jungle flowers, I scattered soft pink blooms on this pastel version of "Tropical Tulips." I used the same basic garden map, but made this version slightly smaller and with a narrower bottom border.

I also appliquéd more flowers on top of the border to balance the quilt. Although I loved the fabric and thought it would result in a delicate pastel quilt, I found that the large areas of solid background on the border strip needed just a few more garden blooms!

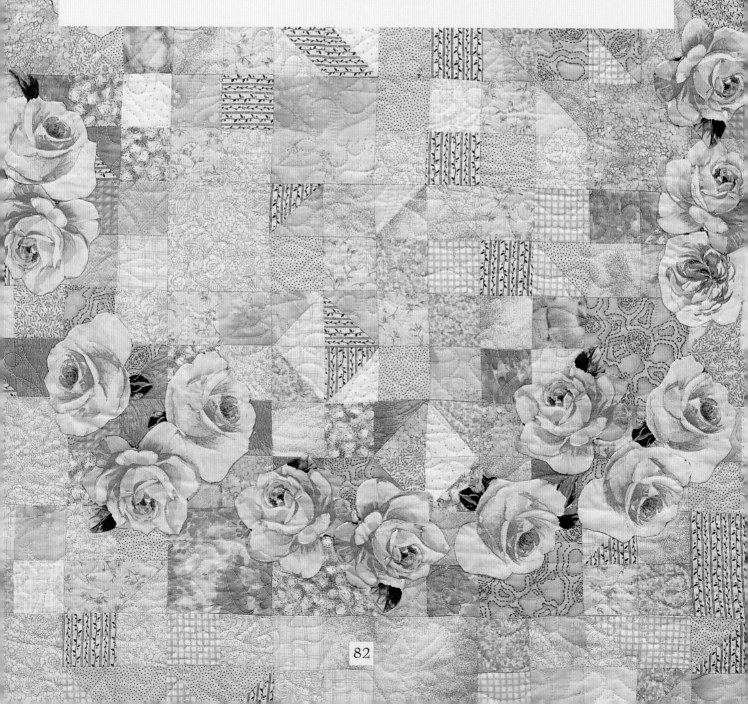

A Garden Wreath

I love making this kind of scrappy quilt! I piece a variety of simple blocks, put them up on the design wall, and move them around until the arrangement seems just right. I'm amazed at how many great designs you can get from just a few basic blocks; it's all about where you place them!

CHOOSING YOUR FABRICS

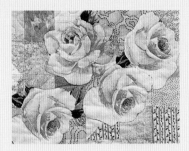

This is your chance to use all those wonderful small pieces from your stash: the more the better! Begin by selecting a focal fabric with flowers that measure about 3" to 5" across, and then choose the colors of your background prints to complement the flower colors. I wanted my background and flowers to blend, so I used the same soft yellow colors for both. For the wreath background, I added light greens in the same value as the yellow background prints.

Materials

Yardage requirements are based on 42"-wide fabric and yield enough fabric to make the entire quilt.

- 1 yard of large-scale floral print for *broderie perse* appliqué★
- 2⅜ yards *total* of many assorted light yellow and light green prints (in small pieces) for blocks
- ⅔ yard of yellow print 1 for border
- 3 yards of fabric for backing
- ⅔ yard of yellow print 2 for bias binding
- 54" x 54" piece of batting

★*Amount will vary depending on the print.*

You're the Designer!

This lovely quilt is different from the others in this book, not so much in how it looks as how it's made. Rather than giving you a few specific blocks to make in specific numbers, I've provided a wide variety of Blender and Background block options to choose from. All of the options are made using the same simple pieces and units. You might choose to make lots of one type of block and fewer—or perhaps none—of the other options. It's all up to you.

Because I have no idea which block options *you'll* choose, it's impossible to list the precise number of different-sized pieces you'll need to cut for the entire quilt. Instead, I've given you a reasonable number of pieces to cut, enough to make about a dozen blocks at a time. Have fun stitching the pieces together in different combinations and putting the blocks on your design wall to see the overall design emerge. I especially like playing with the various triangle-square units. You can create totally different effects depending on how you choose to place the units and whether the fabrics are the same or different shades. The possibilities are endless!

Working this way—with just a small group of blocks at a time—will also help you determine which block options to focus on next, and which fabrics to cut the next set of pieces from. Continue cutting, sewing, and arranging groups of blocks until you have the 100 blocks you need for your quilt: 36 Blender blocks and 64 Background blocks. The block options are the same for both types of block—it's just the colors that are different. The Blender blocks are cut mostly from the green prints, and the Background blocks mostly from the yellows. But, of course, there are bits of the other color in each!

Designing the Quilt

• Position the Blender blocks so that the green areas of the blocks form the wreath shape.

• Choose some yellow prints with a touch of white to add sparkle and dimension to your scrappy palette.

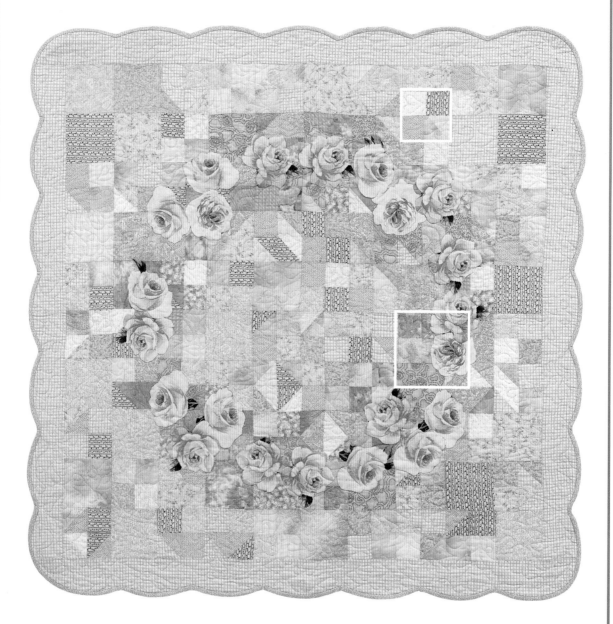

Finished quilt size: 46½" x 46½" • **Finished block size:** 4"

Cutting

Read through all instructions for making this quilt before you begin cutting. Cut all strips across the width of the fabric.

From yellow print 1, cut:

5 strips, 4" x 42", for borders

From the assorted yellow and green prints, cut a *total* of:

30 squares, 2⅞" x 2⅞"

30 squares, 2½" x 2½"

5 squares, 4½" x 4½"

Making the Blocks

You need a total of 100 blocks for this quilt: 36 Blender blocks and 64 Background blocks. You can create an endless variety of both types of blocks from the squares you've cut. I suggest that you begin by using the 2⅞" yellow and green squares to make a few dozen half-square-triangle units as described in the next section, and then combine these units with the 2½" yellow and green squares to assemble the various Blender and Background blocks. Introduce the 4½" yellow and green squares as you begin to arrange the blocks on your design wall. Continue cutting and sewing until you've made the necessary 100 blocks.

Half-Square-Triangle Units

Draw a diagonal line on the wrong side of a 2⅞" yellow or green square. With right sides together, position the marked square on top of another square of a different color or print. Stitch ¼" from both sides of the drawn line as shown. Cut on the drawn line, fold the sewn units open, and press toward the darker fabric to make two half-square-triangle units. Make approximately 30 half-square-triangle units at a time.

Blender Blocks

These blocks form the green wreath background, so select the majority of the squares from the green prints and use the yellow prints sparingly, primarily along the outside edges of the blocks. Make these Blender blocks in any combination of the following configurations, using half-square-triangle units from the preceding section and 2½" assorted yellow

and green print squares. You can also use 4½" green print squares as Blender blocks.

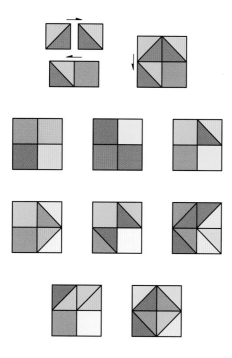

Background Blocks

These blocks form the yellow background that surrounds the wreath, so select the majority of the pieces from the yellow prints and use the green prints sparingly, primarily along the outside edges of the blocks. Make these Background blocks in any combination of the options suggested for the Blender blocks, once again using half-square-triangle units from page 85 and 2½" assorted yellow and green print squares. You can also use 4½" yellow print squares as background blocks.

Putting It Together

This is my favorite part of making this quilt: playing with the blocks until I love the arrangement of colors and shapes!

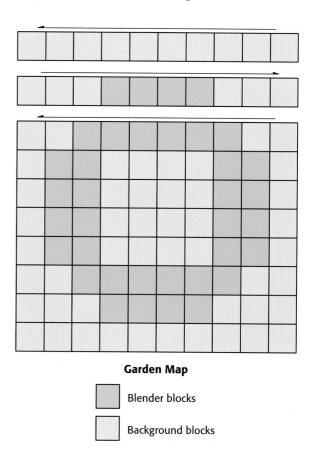

Garden Map

Blender blocks

Background blocks

1. Referring to the photo on page 84 and the garden map above, fine-tune your arrangement of blocks into 10 horizontal rows of 10 blocks each. Have fun rearranging the blocks until the green wreath emerges from the yellow background. When you are satisfied with the arrangement, sew the blocks together into rows. Press the seams in opposite directions from row to row. Sew the rows together; press.

 Undoubtedly you will have some left-over blocks. Save these orphan blocks for a future project, or piece them together for a pillow or table runner.

2. Refer to the photo and "*Broderie Perse Appliqué*" on page 10. Cut approximately 25 to 35 flowers from the focal fabric. The precise number of flowers you need to cut will depend on the size of the flowers in your print and how closely you want to position the flowers on your quilt. Don't forget to add a ¼"-wide turn-under allowance around each piece.

3. Position the cut flowers on the green background to create the floral wreath. When you are pleased with the arrangement, pin the flowers in place.

4. Appliqué the flowers to the background.

5. Refer to "Adding Borders" on page 89 to piece, trim, and sew the yellow print 1 strips to the sides, top, and bottom of the quilt. Press the seams toward the border.

Finishing Your Quilt

Refer to "General Instructions," beginning on page 89, for specific instructions for each of the following finishing steps.

1. Layer the quilt top with batting and backing; baste.

2. Quilt around the outside of the appliquéd flowers, about ⅛" from the edge. Quilt inside the flowers following the outline of the petals. Quilt the rest of the quilt in a favorite allover pattern.

3. Referring to "Scalloped Borders" on page 90, scallop the edges of the yellow border as instructed.

4. Referring to "Bias Binding" on page 93, cut 2¾"-wide bias strips from yellow print 2 to equal approximately 250". Use the bias strip to bind the scalloped quilt edges.

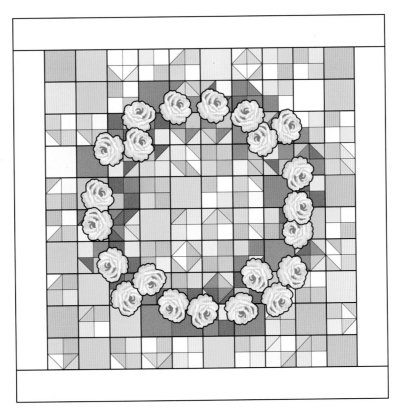

Quilt Plan

Another Look

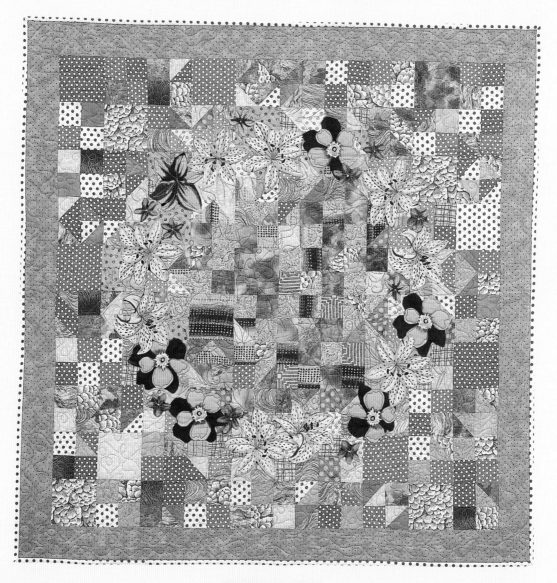

TUTTI-FRUTTI

This quilt looks almost good enough to eat! I used the same garden map as for "A Garden Wreath," but came up with a very different look because of the fabrics I selected. Rather than working with subtle prints in soft tints of two colors, I made this creation from bright and beautiful fabrics in many shades (and prints) of purple, hot pink, orange, and green. Polka dots add an especially playful touch to this Scatter Garden quilt.

I cut several different flower motifs from the same tropical-looking print for the appliqués. Of course, if you'd prefer, you can combine flowers from different fabrics instead. As long as you like the way the colors work, anything goes in the garden!

General Instructions

This section includes helpful instructions for completing the projects in the book. Refer to it if you have questions about specific quiltmaking techniques. (You can, of course, substitute your own preferred techniques for these quiltmaking basics.) To make sure you are pleased with your finished quilt, keep these basic—but very important—tips in mind:

- Cut accurately and consistently, using the same brand of ruler throughout a project.

- Always stitch accurate ¼"-wide seam allowances.

- Press carefully after each stitching step in the instructions.

Adding Borders

1. Measure the length of the quilt top through the center. Cut two border strips to this measurement, using diagonal seams to piece the strips as necessary.

2. Mark the center of the quilt sides and the border strips. Pin the border strips to the sides of the quilt, matching the center marks and ends and easing as necessary.

Sew the border strips in place and press the seams toward the border.

Measure center of quilt,
top to bottom. Mark centers.

3. Measure the width of the quilt top through the center, including the side border strips just added. Cut border strips to this measurement, piecing as necessary. Mark the centers, pin, and sew the border strips to the top and bottom of the quilt. Press the seams toward the border.

Measure center of quilt, side to side,
including borders. Mark centers.

Scalloped Borders

Scalloped borders add a graceful finishing touch to a quilt, and are one of my favorite border treatments. There are several tools on the market to help you make scalloped quilt borders, but I prefer my old standby: the "dinner-plate technique."

Many of the quilts in this book would work well with scalloped borders. Just increase the width of the outer border, if necessary, so it measures at least 6" and follow these steps:

1. After the quilt has been quilted, cut a piece of freezer paper to the same length and width as the top border and another piece to the same length and width as a side border.

2. With the dull side of the freezer paper facing up, position a dinner plate in the corner of the top border freezer-paper piece. Trace around the top edge of the plate to make the first corner. To make the next scallop, move the plate over to overlap the first scallop as much as you wish, and trace around the top edge of the plate. For a slight scallop, overlap a great deal. If you prefer a deeper scalloped edge, position and trace the plate farther from the preceding scallop. Continue along the top until you reach the opposite corner of the freezer paper. If the scallops don't come out just as you like, simply redraw them.

3. Press the marked freezer paper, shiny side down, onto the top border of your quilt. Cut the scalloped edge through the paper and fabric, cutting directly on your marked

line. Remove the freezer paper. Use the same freezer-paper template to mark and cut the bottom border.

4. Repeat steps 1–3 to mark and cut one side border, using the corner scallop from the top border as the starting point. Use the same freezer-paper template to mark and cut the remaining side border. See "Bias Binding" on page 93 for instructions on binding scalloped edges.

Freezer paper

Finishing Your Quilt

The following information will help you give your quilts an attractive, professional finish.

Layering and Basting

The quilt "sandwich" consists of the backing, batting, and quilt top. I recommend that you cut both the batting and the backing at least 4" larger than the quilt top on all sides. For large quilts, you will probably need to sew two or three lengths of fabric together to make a

backing piece that is large enough. Remove the selvages before sewing, and press the seams open to reduce the bulk.

OR

1. Spread the pressed backing, wrong side up, on a clean, flat surface and anchor it with pins or masking tape. Center the batting over the backing, smoothing out any wrinkles.

2. Center the pressed quilt top, right side up, over the batting. Smooth out any wrinkles and make sure the edges of the quilt top are parallel to the edges of the backing.

3. For machine quilting, pin the layers together with safety pins. Begin pinning in the center and work toward the outside edges, placing pins every 3" to 4" over the entire surface.

Quilting

The quilts in this book were machine quilted—the method I prefer for Scatter Garden quilts—but you can choose your favorite quilting method to finish your project. Each project includes suggestions for quilting designs.

Many of today's quilters enjoy the luxury of having their quilts finished by a talented professional quilter, and I'm one of them! All of the projects in this book were machine quilted by my very helpful long-arm quilter, Carol MacQuarrie. If you prefer to do your own machine quilting, check your local quilt shop for books, stencils, or even classes to get you started.

Edi's Binding

My friend and seamstress Edi Dobbins does absolutely fabulous bindings! She agreed to share her technique with you, and I know you'll be pleased with the smooth seams and perfect corners. If you don't have a favorite technique, I highly suggest you give Edi's binding a try.

For a straight-cut, French double-fold binding, cut 2½"-wide binding strips across the fabric width. You will need enough strips to go around the perimeter of the quilt plus about 10" for seams and corners. The project instructions tell you how many strips to cut.

1. With right sides together and using diagonal seams, sew the binding strips end to end as shown to create one long binding strip. Trim the seams and press them open.

2. Press the strip in half lengthwise with wrong sides together.

3. With right sides together and raw edges aligned, position the strip at one corner of the quilt top so the strip extends approximately 1½" beyond the corner as shown. Begin stitching ½" from the corner using a generous ¼"-wide seam allowance.

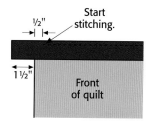

4. Stop stitching ¼" from the next corner of the quilt.

5. Fold the binding strip up, away from the quilt, to form a 45° angle as shown. Fold the strip back down, aligning the raw edges with the adjacent edge of the quilt. Resume stitching at the edge of the quilt with a generous ¼"-wide seam. Repeat at each corner until you come to the corner at which you began.

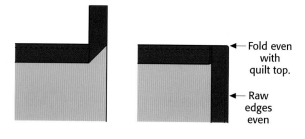

6. As you approach the final corner, flip the binding on the first side so that it folds back over the seam, right side out as shown. Stop stitching ¼" from the seamed edge and backstitch. Trim the excess binding so that about 1½" remains beyond the corner.

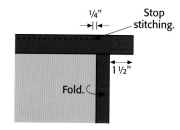

7. Fold the finishing end of the binding right sides together with the starting end of the binding, creating a fold in the quilt. Insert the needle as shown.

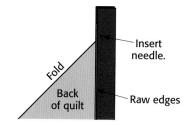

8. Using a pencil or pin, mark the center-point of the binding, ½" up from the point where you have inserted the needle. Stitch to this point, pivot, and stitch down to the folded edge of the binding at a 90° angle. The stitching will form a V as shown.

 Trim the excess binding ⅛" from the stitching line.

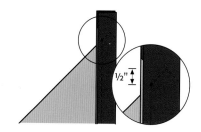

9. Open the quilt so it is right side up and fold the binding over the corner. Poke out the turned corner and pin in place to the back of the quilt. Fold the rest of the binding to the back of the quilt, pin, and hand stitch to finish.

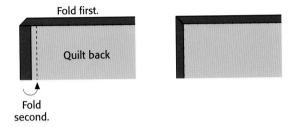

Bias Binding

For curved edges such as scallops, you will need to make bias binding to fit smoothly around those curves. I cut 2¾"-wide strips for my bias bindings.

1. Place a single layer of fabric on a rotary-cutting mat. Align the 45° angle marking on your rotary ruler with the selvage edge of the fabric as shown. Cut 2¾"-wide bias strips to equal the length of binding needed to finish the quilt as indicated in the project instructions.

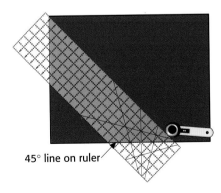

45° line on ruler

2. With right sides together, sew the strips end to end, offsetting the seams by ¼" as shown. Trim the seams and press them open.

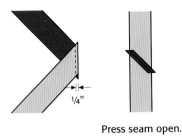

Press seam open.

3. Press the strip in half lengthwise with wrong sides together. Cut one end of the strip at a 45° angle and press it under ¼".

Fold line

4. With right sides together and raw edges aligned, sew the binding to the quilt with a ¼"-wide seam, beginning about 3" to 5" from the start of the binding strip. Gently stretch the binding around the inside curves of the quilt as you stitch.

5. As you approach the point at which you started, trim the end of the binding strip so that it extends ½" beyond the starting point. Tuck the trimmed end inside the starting end and complete the seam.

6. Fold the binding to the back of the quilt and hand stitch in place, easing in fullness at the inside curves.

Facings

Sometimes, to maintain the vertical or horizontal emphasis of a quilt without the distraction of a traditional binding, I prefer to finish the quilt with a facing instead. A facing is not visible on the front of the quilt, and therefore

works perfectly in this situation. The project instructions tell you how many strips to cut. I cut 4½"-wide strips for my facings.

1. Measure the length of the quilt through the center. Piece the facing strips and cut two to the length of the quilt. With right sides together and raw edges aligned, pin the facing strips to the sides of the quilt and sew with a ¼"-wide seam.

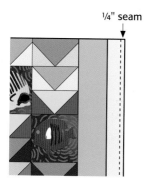

¼" seam

2. From the front of the quilt, press the strips outward and topstitch ⅛" from the seams through all the layers.

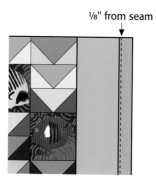

⅛" from seam

Topstitch through all layers.

3. Fold the facing to the back of the quilt so that a slight edge of the quilt top rolls to the back. Press with steam. Turn the raw edges under ¼" and hand stitch them to the back of the quilt.

Back of quilt

4. Measure the width of the quilt through the center. Cut the top and bottom facings 2" longer than the width of the quilt. Center the top strip so that it extends 1" beyond the edge of the quilt on both sides. Repeat steps 1–3 to stitch the facing to the quilt. Tuck in the excess at each end and hem in place. Repeat to add the bottom facing strip.

About the Author

For as long as she can remember, Pamela Mostek has loved making pretty things. She has experimented with and created in a wide variety of media including watercolor, decorative painting, weaving, fabric surface design, and, of course, quilting. If it involves creating something beautiful, she's probably given it a try!

One of her passions is for large-scale, dramatic print fabrics, and she enjoys her ongoing search for new ways to use these irresistible designs in her quilts. One of her previous books, *Just Can't Cut It* (Martingale & Company, 2003), was dedicated to working with these fantastic fabrics in their original state; that is, without cutting them into little pieces.

Fabulous floral fabrics are also the focus of *Scatter Garden Quilts,* only this time Pamela's cutting them into pieces—but very special pieces—using fussy cutting and *broderie perse* appliqué techniques.

Putting her degrees in art and journalism to good use, Pam spends her time creating quilts for her books and her pattern company, Making Lemonade Designs, as well as teaching. She is a proud mother of two grown daughters and grandmother of four very special grandchildren. She and her husband reside in Cheney, Washington

New and Bestselling Titles from

Martingale® & COMPANY

America's Best-Loved Craft & Hobby Books®
America's Best-Loved Knitting Books®

That Patchwork Place®

America's Best-Loved Quilt Books®

NEW RELEASES
40 Fabulous Quick-Cut Quilts
200 Knitted Blocks
Appliqué Takes Wing
Bag Boutique
Basket Bonanza
Cottage-Style Quilts
Easy Appliqué Samplers
Everyday Folk Art
Fanciful Quilts to Paper Piece
First Knits
Focus on Florals
Follow the Dots
Handknit Style
Little Box of Crocheted Hats and
 Scarves, The
Little Box of Scarves II, The
Log Cabin Quilts
Making Things
More Biblical Quilt Blocks
Painted Fabric Fun
Pleasures of Knitting, The
Quilter's Home: Spring, The
Rainbow Knits for Kids
Sarah Dallas Knitting
Scatter Garden Quilts
Shortcut to Drunkard's Path, A
Square Dance, Revised Edition
Strawberry Fair
Summertime Quilts
Tried and True

01/05

APPLIQUÉ
Appliquilt in the Cabin
Garden Party
Stitch and Split Appliqué
Sunbonnet Sue All through the Year
Two-Block Appliqué Quilts
WOW! Wool-on-Wool Folk Art Quilts

HOLIDAY QUILTS & CRAFTS
Christmas Cats and Dogs
Christmas Delights
Hocus Pocus!
Make Room for Christmas Quilts
Welcome to the North Pole

LEARNING TO QUILT
101 Fabulous Rotary-Cut Quilts
Happy Endings, Revised Edition
Loving Stitches, Revised Edition
Magic of Quiltmaking, The
Quilter's Quick Reference Guide, The
Sensational Settings, Revised Edition
Simple Joys of Quilting, The
Your First Quilt Book (or it should be!)

PAPER PIECING
40 Bright and Bold Paper-Pieced Blocks
50 Fabulous Paper-Pieced Stars
300 Paper-Pieced Quilt Blocks
Easy Machine Paper Piecing
Hooked on Triangles
Quilter's Ark, A
Show Me How to Paper Piece

QUILTS FOR BABIES & CHILDREN
American Doll Quilts
Even More Quilts for Baby
More Quilts for Baby
Quilts for Baby
Sweet and Simple Baby Quilts

ROTARY CUTTING/SPEED PIECING
365 Quilt Blocks a Year
 Perpetual Calendar
1000 Great Quilt Blocks
Burgoyne Surrounded
Clever Quarters
Clever Quilts Encore
Endless Stars
Once More around the Block
Pairing Up
Stack a New Deck
Star-Studded Quilts
Strips and Strings
Triangle-Free Quilts

SCRAP QUILTS
More Nickel Quilts
Nickel Quilts
Scrap Frenzy
Successful Scrap Quilts

TOPICS IN QUILTMAKING
Follow-the-Line Quilting Designs
Growing Up with Quilts
Lickety-Split Quilts
More Reversible Quilts
No-Sweat Flannel Quilts
One-of-a-Kind Quilt Labels
Patchwork Showcase
Pieced to Fit
Pillow Party!
Quilter's Bounty
Quilting with My Sister
Seasonal Quilts Using Quick Bias

CRAFTS
20 Decorated Baskets
Beaded Elegance
Collage Cards
Creating with Paint
Holidays at Home
Layer by Layer
Purely Primitive
Stamp in Color
Trashformations
Vintage Workshop, The:
 Gifts for All Occasions
Warm Up to Wool
Year of Cats. . .in Hats!, A

KNITTING & CROCHET
365 Knitting Stitches a Year
 Perpetual Calendar
Beyond Wool
Classic Crocheted Vests
Crocheted Aran Sweaters
Crocheted Lace
Crocheted Socks!
Dazzling Knits
Garden Stroll, A
Knit it Now!
Knits from the Heart
Knitted Throws and More
Knitting with Hand-Dyed Yarns
Lavish Lace
Little Box of Scarves, The
Little Box of Sweaters, The
Pursenalities
Ultimate Knitted Tee, The